THE REGENERATION GAME

ANDY MUNRO

AMBERLEY

First published 2022

Amberley Publishing
The Hill, Stroud,
Gloucestershire, GL5 4EP

www.amberley-books.com

ISBN: 978 1 3981 0944 5 (print)
ISBN: 978 1 3981 0945 2 (ebook)

British Library Cataloguing in Publication Data.
A catalogue record for this book is available from the British Library.

Typeset in 10pt on 13pt Celeste.
Origination by Amberley Publishing.
Printed in the UK.

Contents

Foreword

Birmingham's Jewellery Quarter is famed nationally and internationally, but locally its importance can be taken for granted – as can that of the jewellery trade itself, which has a longstanding connection with our city. Although the working of precious metal in Birmingham can be traced to the later Middle Ages, the origins of the modern Jewellery Quarter are to be found among the late eighteenth-century makers of buckles, buttons and other toys – small metal goods. In particular they fashioned steel into items for male and female wear, moving into silver and later gold when the cost of these precious metals began to fall, a development spurred on by the growth of a middle-class market with disposable income to spend on luxury items.

The jewellers gathered in a distinct part of Birmingham, to the north-west of the town centre in that part of Hockley between Great Charles Street in the east and Icknield Street in the west and Great Hampton Street in the north to the line of Summer Hill Road, the Sand Pits and the Parade in the south.

Despite the national economic difficulties of the late nineteenth century, the jewellery trade continued to grow and by 1908 it had become one of the largest industries in the Midlands. However, problems soon mounted for the jewellery trade. It was badly affected by the First World War, and then during the inter-war years by the Depression, changes in fashion away from ostentatious jewellery, and a shift in middle-class spending towards the purchase of motor cars. After the Second World War, jewellery businesses continued to face pressures, buffeted as they were by recessions, the imposition of a purchase tax, and the growth of imports, while the Jewellery Quarter itself was threatened with destruction. In a period of widespread clearances of whole areas and of redevelopment fixated upon high-rise buildings and American-style freeways, some politicians and planners decried the district as obsolete. They believed that it needed to be scheduled as a redevelopment area so that the old buildings could be torn down and replaced with modern, efficient factories.

It seemed that the forces of destruction would win when part of Vyse Street was demolished and replaced with modern workshop units and the Hockley Centre. Better known as the Big Peg, it opened in 1971 and is named after the wedge-shaped block of wood in the distinctive jeweller's bench. Fortunately, by then opinion had switched to conservation and renewal, and in the ensuing years many Victorian buildings were restored,

allowing the Jewellery Quarter to retain its identity as a distinct neighbourhood. Still, there have been noticeable social and economic changes. The number of manufacturing jewellers has declined while retail jewellery shops, restaurants, bars, residential apartments and museums has risen. As a result, many people now regard the Jewellery Quarter as just a tourist and leisure destination. It is not, and nobody should overlook the ongoing importance of the making of jewellery and its vitality as a business district.

Andy Munro was deeply involved in the Jewellery Quarter during the transformative years of the last generation, and as he makes clear in this insightful and informed work, 'there is a paramount need to retain some significant semblance of the industry if the area is to remain truly unique. Otherwise it will just be another gentrified area with lots of restaurants and bars but very little else and will lose its place as an area absolutely unique in the UK.' Andy's urgings should be heeded, for he came to the district in the late 1990s when the Jewellery Quarter Regeneration Partnership was emerging and he was appointed Jewellery Quarter Animateur. This innovative job title highlighted the originality of the role, for Andy had to encourage participation in regeneration and do so imaginatively and creatively. There was no one better suited to do so than this most passionate Brummie, a maverick who wanted to get things done.

Professor Carl Chinn MBE, Ph.D.

CHAPTER 1

The Vision...
or Maybe The Dream

As a Brummie born and bred in the south of the city, at the age of forty-nine I had never set foot in its famous Jewellery Quarter. This is sadly still the case for many who live to the south of the city and either have never had to commute through the area on their way to work or visited the area to invest in a ring or other jewellery for a big day or event.

In fact, strangely my acquaintance with the Quarter probably owed a lot more to another part of Birmingham – Handsworth. This was because after the 1985 riots, the Government

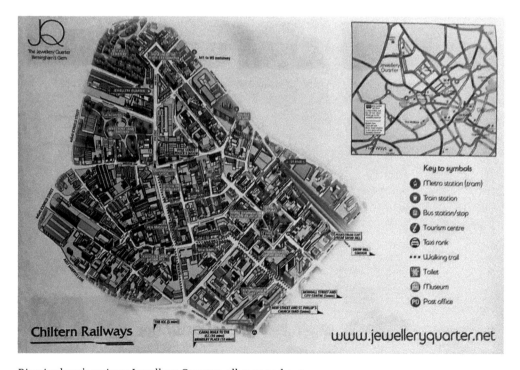

Birmingham's unique Jewellery Quarter, all mapped out.

of the day decided rightly or wrongly that they needed to intervene directly in troublesome areas because they perceived the local authorities as ineffective.

This was the start of a range of initiatives targeted on small geographical areas under the name of Government Inner City Task Forces, each with its own discreet budget answerable directly to Ministers. At the time I was working for the Department of Environment, where typically a successful day's work for a civil servant would be to not make any decisions at all or only make ones that were 100 per cent safe and secure.

The general approach to proposals presented for support, however meritorious, was to primarily look at what was wrong with the proposal rather than to look at how something could be improved to make it happen. A rather depressing attitude in general to life, I always thought!

So when the Task Forces were recruited, I jumped at the opportunity to escape a safe but boring cocoon and from that moment I was sold on getting out of the 'ivory tower' and having the opportunity to be in the midst of real inner city communities.

One of the last Task Forces in Birmingham was the Newtown and Ladywood Task Force, and I took over as Task Force Leader in the 1990s shortly before the end of its tenure. The man in situ before me, John Dickenson, seemed an archetypal civil servant in terms of his plummy accent but in reality was a real regeneration entrepreneur and a popular figure in the community.

With a year left, he was keen to see the succession strategy addressed, a much hackneyed phrase in regeneration but absolutely vital for future sustainability. With a vibrant community, most of the projects on both the deprived Newtown and Ladywood housing estates were being put to bed or being handed on. However, the Jewellery Quarter with its tiny residential population of a few hundred and its somewhat secretive jewellery trade was a bit of a conundrum.

Consequently, John met with the then vibrant environmental organisation Groundwork (Birmingham) and agreed post-Task Force funding for a Jewellery Quarter 'Animateur'. The view was that, given my experience in Handsworth, and my frustration with the mainstream civil service (and probably their frustration with me), I could be that person especially given that in the mainstream civil service I was seen as a bit of a maverick.

Up until this point, regeneration in the Quarter had been in the hands of an organisation called URBED (Urban and Economic Development), who initially had been commissioned by Birmingham City Council to prepare a regeneration strategy for the area and had gone on to run a three-year programme of regenerative actions and activities in the area under the banner of 'Jewellery Quarter Action'.

Almost with impeccable timing, the Prince's Foundation, mainly it seemed at the behest of Prince Charles, wanted to roll out the concept of the Urban Village – such it seemed was the perceived success of Poundbury. However, the Foundation saw this model working across a myriad of areas in need of regeneration. Negotiations took place with a number of local authorities and central government and out of the deliberations, Birmingham's Jewellery Quarter was chosen as one of the Urban Village initiatives.

If one were cynical, it could be said that the Prince's Foundation wanted some of the chosen areas to already be in a relatively good position. Hopefully, this would near enough guarantee success and therefore good publicity, and the Jewellery Quarter fell

Prince of Wales gates, in Spencer Street, by Royal appointment!

into that category. From the local authority point of view, the kudos of being part of a high-profile regeneration initiative with in principle support and financial backing from the Government through their Regional Development Agency must have triggered pound signs, though the proposed level of support never materialised in the final analysis. At the time, the words 'gift horse' and 'mouth' must have sprung to mind for a cash-strapped authority.

In 1998, Birmingham City Council, English Partnerships (the forerunner to the Regional Development Agency) and the Urban Village Forum (the regeneration arm of the Prince's Foundation) commissioned consultants EDAW to develop an Urban Framework Plan for the Jewellery Quarter. This included an audit of the area, its issues and the opportunities therein.

The resultant Urban Framework Plan detailed a list of development opportunities and some target outputs. Interestingly, and perhaps encouragingly, twenty years on almost two-thirds of the development and environmental opportunities have been delivered or work started, which could be considered a success or otherwise depending on how you looked at it.

Another important aspect to the Framework was the development of a Conservation Management Plan, in 2002, to try and ensure there was the right balance of mixed use. This was vital as the majority of owners of buildings and other speculators must have rubbed their hands with the prospect of getting their hands on the developer's version of Willy Wonka's golden ticket.

However, it is the main outputs to the Plan that are perhaps a real key to measuring the success of the Urban Village concept. While more detail will be revealed in subsequent chapters, these were the main objectives that underpinned the Plan:

- 2,000 residential units comprising of a range of types and tenures providing for a full range of people wishing to live in the city centre, creating a residential population of 4,000 to 5,000 people.

Certainly the population figure has been exceeded, but the jury must be out on the range of tenures and the diversity of the population, who are mainly young white professionals with a dearth of new housing association properties. In fairness, this profile is bolstered by some retirees and the fairly strong presence of an LGBT community.

- A healthy living centre providing for the community's health needs.

If you count the Jewellery Quarter's own health centre and pharmacy, then this has been achieved.

- Prioritising new and refurbished workspace of approximately 10,000 square metres, 50,000 square metres of underused or vacant space coming into new use.

Probably now achieved or almost reached, with an excellent choice of accommodation for small and creative businesses.

Above: Rowntree Housing in Charlotte Street, one of the first residential developments in the Quarter.

Right: Regent Place townhouses, a later residential development fitting in well with the street scene.

• Opportunities for new leisure and retail activity and entertainment venues.

If the number of burgeoning restaurants, hotels and the occasional keep-fit facility count towards this output, then it has certainly been met.

• Retail facilities including a neighbourhood convenience store, one on the city fringe, and small convenience stores.

Left: Health centre and pharmacy in Warstone Lane – a must for a burgeoning urban village.

Below: Sovereign Hall in Frederick Street. One of the many conversions from manufacturing to office space.

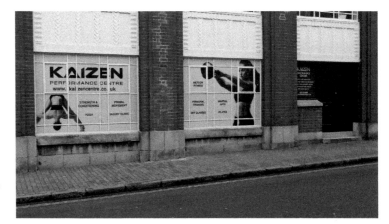

Kaisen Gym in the Argent Centre, Frederick Street. One of the many independent gyms springing up to serve a growing young community.

Button Factory in Frederick Street, from buttons to beer!

Again this has probably been met largely thanks to Tesco's with two Metro-style stores.

There was also a mention of a greater variety of speciality shops, but this hasn't really transpired to any significant degree (unless you count the large number of hairdressers, barbers, beauticians and tattoo parlours) as there is a continuing preponderance of jewellers.

- A Jewellery Design Centre to provide exhibition, retail and workspace creating a new visitor focus.

A dream for many but never fully achieved on the scale envisaged, although there is an outlet set up on Caroline Street to showcase leading design with a workshop facility to the rear.

- Security package including CCTV.

The latter was achieved before being undermined by local authority and police expenditure cuts, which affected their maintenance so they fell out of use. The removal of the local police station was also a negative factor.

Frederick Street Precinct.
A typical soulless suburban
shopping centre thankfully
not repeated elsewhere in the
Quarter, where the independent
is still king.

Intricate jewellery making
is very much alive in
today's Quarter.

- Urban teleworking centre.

This never got past the consultant's drawing board.

- Employment opportunities for existing and new industries including the safeguarding of existing jobs.

A patchy result on both counts with a continued, if gradual, reduction in jobs in the jewellery trade balanced to a modest degree by jobs in the service sector.

- Environmental improvements including street enhancement schemes and improvements to key open space features.

These have happened in part, although sometimes with some purist resistance from the City Council's conservation team. Ongoing improvements to the historic cemeteries and the Golden Square project have been a real plus, despite various obstacles in securing funding.

- Improve pedestrian links and connections.

Key Hill Cemetery gates, a fitting entrance to this historic cemetery.

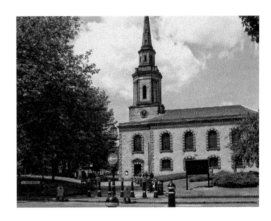

St Paul's Square, where the Jewellery Quarter began. Now Birmingham's last remaining Georgian Square.

Generally a disappointing display in achieving this output, although some limited tree planting, improved street lighting and the pavement trails have been positives. However, the major new development of Paradise Circus may help unlock routes into the Quarter to a better degree.

- Initiatives to reduce supervision of car parking to improve the quality of environment.

Parking remains a massively controversial issue to businesses who feel that the residential developments are responsible for the squeeze on available car parking, exacerbated by developments on 'gap' car parks. An additional issue is the fact that many car parking facilities in new developments attract a premium price and are therefore a disincentive for use by the residents of those developments, who would then rather park on street.

- A structure for delivering the Urban Village.

This happened with the creation of a Jewellery Quarter Regeneration Partnership, now subsumed by the Jewellery Quarter Development Trust and the Business Improvement District.

So there we have some bald facts but much lies behind those objectives and comments, not least lessons learned on success and failure.

CHAPTER 2

Power to the People

Most regeneration initiatives have a high profile with substantial government funding, of which Housing Action Trusts, City Challenges and Development Corporations are all examples.

However, while the concept of Urban Villages was seen as a Prince of Wales' initiative, the funding was more of the ad hoc sticking plaster variety. In fairness, the 'royal' profile was an advantage when applying for main programme or EU funding, but there was no specific programme in place for Urban Villages.

Initially and fortunately, my involvement as the Jewellery Quarter Animateur gave me a very wide brief to move things forward.

A Jewellery Quarter Urban Village Partnership Board was initially set up with representatives from the residential and commercial communities, central and local government, and other prospective funders. However, in its first iteration, the Jewellery Quarter Urban Village Board was headed by a chairman who, perhaps unfairly, was seen by many to be autocratic, arrogant and dismissive of any views that he did not share. It soon became clear that the funded Urban Village Director and he did not see eye to eye and there was only going to be one outcome, with the casualty not being the chairman!

This worked quite well for me as, by default, the Groundwork/Inner City Taskforce became the main officer presence in progressing the wishes of the Urban Village Board. However, the main problem was the need to have a support team, which was eventually sourced from a mix of posts funded by the Regional Development Agency and Europe, and what can only be described as a strange mix of waifs and strays on secondment from the City Council.

In the latter case, this was because a number of City Council managers saw this as a golden opportunity to farm out problem staff. In fairness, this was not always the case and over the ten years of operation there were a few very hard-working, dedicated staff 'nuggets' but also unfortunately, on some occasions, the opposite.

When there was a problem it was very difficult to sort because, on the one hand, I did not want to spend all my productive time dealing with staff problems at the expense of projects. However, on the other hand, the trade union approved disciplinary procedures for local authority staff meant that unless they had attempted to mortally injure somebody

or had stolen the proverbial crown jewels, moving through any disciplinary action was massively time-consuming. Some of the less scrupulous staff knew that.

The Partnership Board itself tended to meet bimonthly and was fairly representative, with membership including local business organisations, the growing residential community, a smattering of local politicians and City Council officers. Even this, however, came with an undercurrent of local politics.

For example, the business organisations were represented typically by the British Jewellers Association (BJA), the Jewellery Quarter Association (JQA) and the Jewellery Quarter Marketing Initiative (JQMI). Unfortunately many jewellers rightly or wrongly thought the BJA was a bit of a white elephant and therefore were not members of that Association and did not see them as representative.

The Jewellery Quarter Association had lots of business members, but was controlled by Marie Haddleton, the publisher of the local trade magazine, the *Hockley Flyer*. She was undoubtedly love-or-hate material to many people in the community. Yet, she was a passionate defender and advocate for the Jewellery Quarter and its trade. Strong characters in the community, like Marie, are usually a force for good when trying to push things forward.

Alongside Marie in the business community was a similarly outspoken character called Ken Schofield. Ken used to run a large antiques indoor operation in the Broad Street part of the city but moved into the Quarter to develop something similar. Unfortunately, it never really took off despite the listed building he bought in Frederick Street (now a hotel) being a treasure trove of antiquities. Ken was a real character, well known for striding around the Quarter in a selection of different hats and waistcoats, but the best thing about Ken was he was fearless and cowed by no one ... a very useful ally to have especially when trying to drive through mountains of red tape to get things done.

The area had a fundraising initiative called the Jewellery Quarter Advertising Fund, which was almost exclusively aimed at promoting the jewellery and giftware businesses in the area. However, in 2007, the Chair, Bob Dewsberry (who incidentally was one of the

Marie Haddleton, the queen of the Jewellery Quarter in her pomp.

Above left: Once a quirky antique centre in Frederick Street, now a hotel.

Above right: Kenny Schofield, an influential figure and one of the many one-off characters in the Jewellery Quarter.

Fund's few non-jewellers) restructured its purpose and membership by appointing Anna Gibson. Anna, who had been Communications Manager at Marketing Birmingham, was a dynamic addition who shook up and galvanised the Fund and the area's marketing under a new banner, the Jewellery Quarter Marketing Initiative (JQMI). This was at a time when there was a suspicion that some of the older Fund members were more set on property development than the marketing and continuance of the jewellery and allied trades.

Even better, from an income point of view, Anna structured the initiative to pull in matched funding on the private sector investment, backed up by a strategic marketing plan for the Initiative, which had been sadly lacking until her appointment. This was critical in convincing public sector and other prospective funders that the Jewellery Quarter was being strategic in its marketing rather than just using the money in an unambitious way on press advertising.

However, the most difficult constituency to represent was the residential community. Growing fast with over twenty different apartment blocks/developments even in the early stages, many were hidden away behind security doors and gates and the only people that seemed to know the way in were councillors at election time.

This meant that representation was a bit one dimensional, people from the same block sometimes being involved in the Forum through word of mouth instead of representing residential apartments across the Quarter.

It soon became obvious that the Partnership needed to be underpinned by a more inclusive structure, so a number of subcommittees were formed. A Jewellery Quarter Neighbourhood Forum for residents was set up and we also formed a Jewellery Quarter Restaurants and Bars Group, where the police were also represented. This worked well and, surprisingly, there ended up being very few incidents of tension between local residents, businesses and late night bar establishments.

The Jewellery Quarter Marketing Initiative was also widened out to discuss and implement a broader approach to raising footfall. Anna worked tirelessly to provide the match funding to achieve these aims while organising festivals and events to draw in visitors.

Another important committee was the Land and Property Group, set up to look at planning applications and also to decide on the use of Section 106 planning gain monies. In some ways this was one of the first attempts to involve the community in having a say in how planning gain monies could be maximised and influenced by the very communities it was meant to support.

This was quite groundbreaking in that the City Council planners had been the main influence in deciding how Section 106 should be used, but in the case of the Jewellery Quarter the major influence swung back to the community thanks to this new group. In fairness to the planners, they adopted a flexible approach to the issue, understanding how important these resources were and how they could be used more importantly as a match for both EU and other funding. As you might imagine, debate was lively with more than a few hidden and conflicting agendas given the presence of both the residential and commercial communities, planners and local councillors to name just a few of the members.

Additionally those committees, there were meetings involving a developers' group and also the Jewellery Industry and Innovation Centre, which discussed jewellery industry support.

As well as all these committees, there were regular council ward meetings with the Jewellery Quarter being part of the massively deprived Ladywood ward. As the sole representative from the Jewellery Quarter, I had to endure a few difficult moments as I suppose I was seen as the 'rich uncle' on the fringe, bearing in mind most of Ladywood's comparatively stark deprivation. However, it is fair to say that the Council trio of Albert Bore (then leader of the Council) Carl Rice and Kath Hartley could not have been more supportive. Although maybe it helped to have a growing population of voters in the Quarter!

The Canal 'Ring' Bridge in Fleet Street, an appropriate addition to the canal scene in the Jewellery Quarter.

At that stage, the Jewellery Quarter was an exception in the city centre in that the area was not one of the rapidly increasing number of Business Improvement Districts (BIDS). However, we still participated in their regular get-togethers, which was a useful forum for both sharing best practice and picking up some useful tips.

In truth, there was barely an evening to spare in terms of meetings and events, as I soon learned that to be complacent and miss out was not taken too kindly by other committee members and, in any event, it would have been a missed opportunity to develop something or cultivate useful contacts. It also showed that we were serious in wanting to be part of the heart and soul of the community.

I suppose, looking back, the one thing that could have been strengthened was relationships and initiatives impacting on the wider ward and certainly our many committees and meetings lacked diversity. Yes, we had representation from the thriving LGBT community, but there was a distinct preponderance of white male faces, although in fairness that might have been a general reflection on the residents living in the Quarter and certainly reflected the jewellery industry at the time, which, apart from designer makers, was very male dominated – particularly at management level.

One of the other issues was whether the facilities in the Quarter were sufficient to persuade couples who had young children to stay. With the exception of St Paul's Square, the only green space was the cemeteries. Hardly a good playground for young children!

There is now a secondary academy school, although its main clientele are inner city children. In the younger age group, there are nurseries but no primary school has actually opened in the area, although there are some quite close, albeit outside the JQ boundary.

In gauging a 'community' view looking back on the area's regeneration, I decided there could be no better person to have a word with than Marie Haddleton (sadly now passed).

The Academy, a much needed secondary school in the Quarter and a creative conversion of Severn Trent Water Authority's previous offices in Newhall Street.

Marie was something of a legend in the Jewellery Quarter and was born in Tenby Street, with her dad being a local policeman based in the police station that was in Kenyon Street. He was apparently seen as something of a local hero when he saved eleven people from drowning during the Hockley Floods.

Marie started the *Hockley Flyer*, the go-to magazine in the Jewellery Quarter, because she felt that so many people in the jewellery trade were isolated and there needed to be something to bind that community together. The monthly magazine started in 1985 and was still going in 2020 as a printed publication with the support of her son Mark. Never afraid to say what she felt was necessary on behalf of small business, she was even shortlisted for 'Regional Journalist of the Year' for her services campaigning for small business.

Marie also started the Jewellery Quarter Association, which was triggered when there was an uproar when parking control was transferred from the police to Birmingham City Council with plans to have the same rates and regulations as those in the city centre. Marie stepped forward to lead a vigorous and successful campaign against those proposals.

Interestingly there was also an association started called the St Paul's Club, which was originally seemingly just for the owners of large and jewellery-related businesses. This was perceived by many as a chauvinistic gathering to which women weren't invited or welcome as equals.

The *Hockley Flyer*, the monthly Jewellery Quarter trade bible.

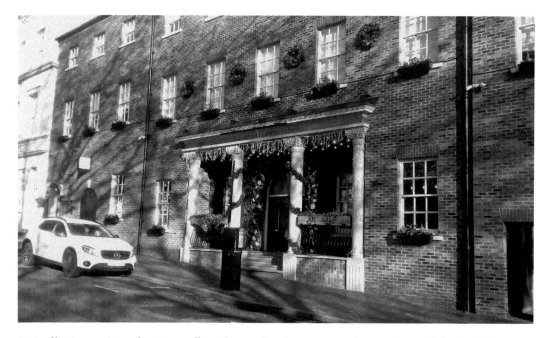

St Paul's House. Once the Ropewalk and now the chosen venue for meetings of the Jewellery Quarter Association.

Marie was allowed in as a guest just once, as I was, to sample the delights of lots of chuntering and a traditional dinner of boiled beef, cabbage and potatoes – not my most memorable meal, nor Marie's! Perhaps it was no surprise that Marie, despite her gender, was invited into the hallowed rooms of St Paul's Club as she was seen as a powerful and influential figure as a sometimes outspoken member of Birmingham City Council's Conservation Committee. She was even alleged to have a hotline to HRH Prince Charles, whose architectural love child could be said to be the Jewellery Quarter.

I asked Marie about the effectiveness of the various initiatives that had impacted on the Jewellery Quarter, which really started with the Inner City Partnership Scheme where grants were made available for building owners to improve the façades. This was followed by the appearance of URBED, a regeneration agency who were chosen by the government's City Action Team to support the Quarter's ongoing regeneration.

Rather pleasingly for the people who worked hard with me, Marie said that she felt that the Jewellery Quarter Regeneration Partnership was by far and away the best initiative because of its accessibility and its approach to street level and not just strategic or flagship project issues.

In terms of the Urban Village, Marie felt that the biggest mistake was to announce that initiative without having the Conservation Management Plan in place at the same time. She felt that the Conservation Management Plan was a major protector of the character of the area and came in a little too late, when some architectural 'damage' had already been done. She did feel, however, that having a Design Guide was a good thing in limiting the amount of tall buildings, which had helped retain the character of the area since its implementation.

Finally I asked Marie what her dearest wish for the Quarter was, and she felt that if the Quarter could still be the home of local jewellers making locally made jewellery then its unique character would always remain.

One thing is certain: with the shopping trolley she famously used to deliver copies of the *Hockley Flyer* across the Quarter now immortalised in the Quarter's pavement trail, she will never be forgotten!

To get a resident's viewpoint, I spoke to Matthew, who has a fairly typical profile for a Jewellery Quarter resident as an ambitious young white professional. I asked him why this profile tended to be the case and he pointed out that to buy property in an aspirational area like the Quarter obviously needed to be supported by a decent salary. However, he also pointed out that there was a fairly substantial population of retirees who wanted to be in walking distance of the city centre to enjoy the theatre and other cultural activities, while living in an area with a proper range of facilities.

Matthew was a born and bred Brummie from Weoley Castle and at the time of the interview worked as a Project Design Manager for a large construction company. It made sense for him to be near the city centre, given his UK-wide brief, and he originally lived in King Edward's Wharf off the Broad Street area. However, he told me that he found the Jewellery Quarter far better in terms of both facilities and a proper community spirit. On the latter point, while many apartment blocks have security access only, he felt that the plethora of events, festivals and meeting places such as coffee shops and bars encourage a community spirit, allied, of course, to a very active social media.

Matthew has been one of the leading lights in the community in developing a Neighbourhood Plan with the City Council, first proposed in 2014, which aims to underpin the Quarter's ongoing progress. Predictably, I asked him about the possible tension between residential development and the jewellery trade and other industries. However, with the help of the Neighbourhood Plan, Matthew was very upbeat about the future of both the creative and jewellery sectors in the area, despite the pressures of residential development.

In conclusion, when I asked Matthew about the strengths of the area, he summed it up with words such as strong identity, history, character, good facilities (to both businesses and residents) and, last but not least, an active community.

CHAPTER 3

Early Days and Early Wins

One of the first issues in any regeneration initiative is to not only to get to know the main players in the community but get them onside, especially as communities are usually suspicious about what they see as somebody just being parachuted in. On the other hand, from a public sector viewpoint the danger is thinking the community that presents itself is automatically fully representative. Sometimes that 'community' can consist of those that shout loudest but then disappear swiftly from the scene when their pet project or idea is delivered.

Either way, it was important to hit the ground running and I was particularly lucky to be seconded to Groundwork Birmingham, as the Jewellery Quarter Animateur in 1998. Both their CEOs at that time, Ian Nichol, and his successor Clive Wright, were masters at accessing money and had a wealth of knowledge about community issues.

However my first few weeks consisted of walking around the area and meeting some of the Quarter's major players. The walk around was particularly important because of my typical shameful lack of knowledge on things north of Birmingham city centre.

To say that I was fascinated by both the architecture and the history of the area was an understatement. From learning for the first time that Birmingham was once a world centre of pen nib making to finding manufacturers making anything from whistles and top line cutlery to Lonsdale belts and Queen's Birthday Honours, it was an education in the city's fabulous heritage. To be honest, I felt ashamed as a *c.* fifty-year-old Brummie to only just be realising how important the area was to the city's history.

One thing was certain and that was the area definitely looked like it needed some tender loving care. It also patently needed some consistency in the street furniture to give a sense of place to visitors and to differentiate the exact area that made up the Jewellery Quarter.

The Quarter, at the time, was mainly a mix of jewellery-related retailers, a few 'greasy Joe' cafes, some large or not so large jewellery-related and other 'metal bashing' manufacturers, and a very small residential population of around 400. This was all a far cry from the Urban Village vision that had been set out.

To start the ball rolling, I met with the City Council planners to establish exactly what area was meant by the Jewellery Quarter. While it was generally agreed the boundaries

were Sand Pits, Icknield Street, and Great Hampton Street/Constitution Hill, some of the planners bizarrely suggested there should be a buffer zone between the Newhall Street part of the Jewellery Quarter and Great Charles Queensway, which was seen as a border of the city centre.

Hence the Jewellery Quarter gateway sign that we erected can be seen on the corner of Lionel Street and Newhall Street, creating a gap between the city centre core and the Jewellery Quarter, which to my mind was completely illogical in terms of raising the profile of the Quarter when a smooth transition between the areas made more logical sense so as not to create any confusion among pedestrians.

Either way, my first thought was to try and give the street furniture a Jewellery Quarter theme. Lighting columns were generally in a tatty condition and were either unpainted or in an assortment of colours. I thought black and gold would look smart, with claret and gold the alternative proffered by the City Council design team. Luckily for me, (being a Birmingham City fan), I managed to persuade the Urban Village Board to opt for black and gold.

However, the City Council Highways Department had no money and the Regional Development Agency certainly were not going to fund something they saw as the responsibility of the local authority. On that basis, with the support of Groundwork, we rather optimistically bid for EU funding, which was initially laughed off by the Central Government Office, the custodians of funding. This was despite my civil service connections.

At around this time I'd also done some research on pavement trails and read about the Fish Trail in Hull. It seemed to me that we needed to make the history of the area more accessible to visitors and our own pavement trail would help do that. So this was added to a revised bid to the Government under the title of corporate street theming. Amazingly the revised bid was approved in principle and we then worked on more detail.

In my experience, the most negative people in a local authority bureaucracy work for the Highways Department. They always seemed to prefer to discuss what could not be done or was too difficult rather than what was possible. In anticipating this attitude, I had

Newhall Street gateway sign, one of four in the Quarter.

detailed discussions with Hull City Council to establish how their pavement trail slabs had been fitted and whether they had any maintenance problems, which fortunately they did not. This proved a successful line of defence to the doubters at Birmingham City Council's Highways Department, so my next step was to write a brief and go out to tender.

Of course, regeneration is often about learning from mistakes and I had already committed a few! At the time there was a part-funded Government organisation called PACA (Public Art Commission Agency), based in Birmingham, and, in 1998, I had initially asked them to oversee a competition to design a Jewellery Quarter logo that we could use to support the identity of the area. The idea was to use this on street furniture and for general branding.

As somebody lacking in artistic skills to the extent that I wasn't even allowed to take art at 'O' level, I took a back seat on the judging panel on the designs. A big mistake from which I quickly learned that you don't really need to be an artist or design guru to identify a logo that can be both easily recognised and enjoyed by members of the public.

However at that time, in my naivety, I let the 'experts' on the panel hold sway and they came up with an abstract design that apparently reflected the street grid in its lines while the circles in the design were supposed to represent products made in the area. Needless to say, the public never got it and the signs gradually disappeared from the street scene over the years. Perhaps it is no surprise that PACA are no longer in existence.

In contrast, for the pavement trail, I compiled a list of thirty interesting facts about the Jewellery Quarter and the task for tendering artists was to be able to translate them in a humorous or quirky way. Just as importantly, they were expected to have a robust game plan on installation.

It was decided to have two trails with two separate artists with their own unique take on things. It proved a real success, with the successful artists including a partnership called Renn & Thacker, who had an award-winning reputation in public art, and Laura Potter, a graduate from the School of Jewellery. In truth, there was a bit of political pressure to make sure that one of the artists was a graduate from the school, although, in fairness, Laura was a gifted artist and designer.

Art for art's sake? The initial regeneration logo, which unsurprisingly never caught on.

24

The other successful tenderer, Renn & Thacker, had subsequently successfully bid for commission using planning gain monies for a charm bracelet lock at the bottom of Newhall Hill, so their pavement trail up to the clock became the Charm Bracelet Trail.

It included references to Acme Whistles, who made the *Titanic* whistles; the FA Cup, a version which was made by Fattorini who had a factory in Frederick Street; and even a slab depicting Rip Van Winkle to celebrate the fact the classic book was written in the Jewellery Quarter by author Washington Irving when he was over from America visiting relatives.

The slabs for the Charm Bracelet Trail are not insignificant block bronzes and we were keen to have them in place for a Jewellery Quarter Festival that we were organising. The installation unfortunately fell behind schedule and the responsible party, Birmingham City Council Highways, had the not so bright idea of gluing these valuable slabs in place.

Luckily we found out almost straight away, realising that however super the glue was, the bronzes were likely to disappear overnight. Renn & Thacker's installation plan included metal spikes underneath the plate which could be concreted in to be safe and secure, After much muttering, huffing and puffing from the Highways Department, they agreed to reinstall to the full specification.

The Findings Trail by Laura Potter was less problematic as the materials used were less valuable. They celebrated everything from the Assay Office anchor mark and the invention of celluloid at the Elkington's factory (subsequently the Old Science Museum) to a nineteenth-century rollercoaster called 'the Russian Mountains'.

Both trails incidentally still produce a lot of comment and interest from pedestrians and perhaps a test of sustainability is that only one of them has been vandalised in almost twenty years.

The trails are listed below as described in a published leaflet, unfortunately now out of print:

THE CHARM BRACELET TRAIL (along Newhall Hill and Frederick Street)

1. The Key: the start of the trail.

2. Silent Boots: in the 1980s, plain clothes officers in the Jewellery Quarter were issued with 'silent boots' to apprehend thieves.

3. Rip Van Winkle: Washington Irving's classic tale was written during his stay in the Quarter, at a cottage which was located on the corner of Legge Lane and Frederick Street in 1818.

4. 1832, 200,000 Chartists met here: one of the largest public gatherings in that year to campaign for parliamentary freedom.

5. The FA Cup: designed and made in the Jewellery Quarter.

6. Whistles for the *Titanic*: made by a Jewellery Quarter firm J. Hudson Limited (now Acme Whistles). They still manufacture these whistles on the original equipment today, along with football's famous Acme Thunderer.

7. Matthew Boulton: commemorates Birmingham's famous industrialist.

8. Turkish Baths: outside the Argent Centre, once the home of pen manufacturer W. E. Wiley, who used recycled steam to operate a health club and Turkish baths.

9. Anchor: commemorates Birmingham's famous Assay Office, established since 1773 with their famous Anchor mark.

10. His Nibs: adjacent to a pen factory which was part of a Birmingham trade that went on to produce 75 % of the world's steel pen nibs.

11. The *Hockley Flyer*: the Quarter's famous trade magazine, once personally distributed by the magazine's editor and local historian Marie Haddleton.

12. Shrapnel: outside one of the Jewellery Quarter's most famous badge making firms, which was targeted by the Germans in the Second World War.

13. Bits for Spitfires: Spitfire machine parts as well as commemorative metals for the war effort were made in the Jewellery Quarter.

14. School of Jewellery: commemorates Birmingham's internationally famous School of Jewellery, opened in 1890.

15. Peas like Emeralds: Frederick Street, once the location for Vittoria Restaurant – a culinary jewellery landmark for many years. The inaugural menu boasted 'small chickens properly cut and mounted and small peas like emeralds'.

16. The Chamberlain Clock: the Quarter's famous landmark clock erected in 1903 to commemorate Joseph Chamberlain's services abroad.

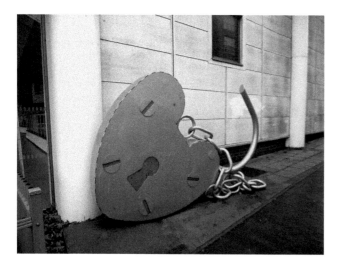

The padlock in Newhall Hill, appropriately the start of the Charm Bracelet pavement trail.

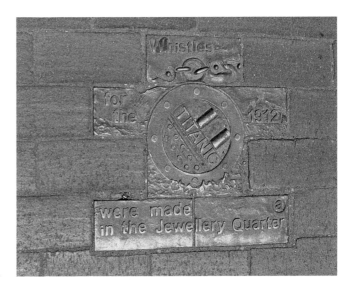

Celebrating the *Titanic* whistles made in the Quarter.

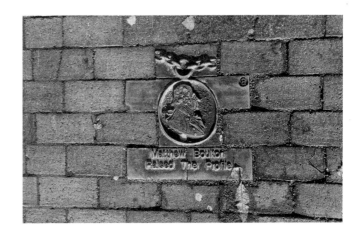

Commemorating Birmingham's famous industrialist Matthew Boulton.

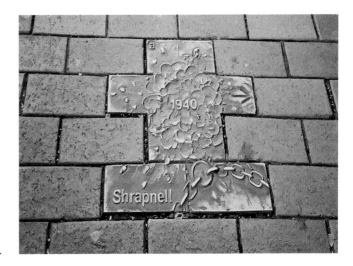

Outside Fattorini, famous badge makers who were targeted by the Germans in the Second World War as they made parts for Spitfires.

THE FINDINGS TRAIL (along Newhall Street and Graham Street)

1. Heart: the start of the trail, which leads you to the heart of the Quarter.

2. Tunnel: Newhall Street is the centre of the city's telecommunications network, with five or six miles of secret tunnels underneath.

3. Precious Metal Symbols: used in hallmarking.

4. Beer Bottle Tops: the legend that the Anchor symbol used by Birmingham's Assay Office was chosen in a pub called the Crown & Anchor. On the toss of a coin Sheffield won it and chose the Crown and Birmingham were left with the Anchor.

5. Church Symbol: turn right into Birmingham's only remaining Georgian square and the famous Georgian Church of St Paul's.

6. Slippery Road Sign: once a site of a roller coaster called the 'Russian Mountains'.

7. Empty Paint Tubes: turn right into Brook Street to visit the Royal Birmingham's Society of Artists (RBSA), formed in 1812.

8. Rubber Teats: down Brook Street into St Paul's Square, once a popular promenading spot for Victorian nannies and nicknamed 'Titty Bottle Park'.

9. Borax: vital to a jeweller, where solid blocks of borax are ground down to be used as flux base for soldering.

10. Inkwell: outside Baker & Finnemore, who were one of the firms famous for pen nib making.

11. Casting Tree: used by the jewellery trade for the production of multiple objects.

12. Building Bricks: on the corner of Vittoria Street, the location of Birmingham's School of Jewellery, which is over a hundred years old.

13. Flag: part of Victoria Works, locally known as Flag House, which was once a famous pen nib making factory.

14. Signatures: the owner of Victoria Works, Joseph Gillott, who perfected a technique of mass producing steel pen nibs. Visitors to this factory included General Ulysses Grant and other famous people from 'across the pond'.

15. Cross: the meeting with the other pavement trail.

16. Heart: start of the trail back to the city.

17. Running Man: a frequent sight in the jewellery trade were couriers running from place to place.

18. Steel Bangle: near to the Sikh Gurdwara Temple. The steel bangle is a religious sign. A building with a spiritual history previously occupied by Congregationalists, New Methodists and the Elim Tabernacle.

19. Farthings: commemorates historic Birmingham Mint that used to be in the Quarter.

20. WMT Buses: this building was once headquarters of Birmingham's famous cream and navy blue buses, in a location that was once home to wealthy manufacturers looking out onto open country.

21. Curb Chain: chain-making was one of the many skills practised in the Quarter.

22. Chocolate Bar: Birmingham is famous for its Cadbury's chocolate with its 'solid gold' strap line.

23. Taps: near to a building that was once the long-time headquarters of the Severn Trent Water Authority.

24. Bench Peg: another tool of the trade that jewellers used to make their jewellery.

25. Plated Sample: near the old Elkington Works where electroplating was introduced.

26. Film Projector: celluloid was another invention by the Elkington factory. Hollywood owes it to Birmingham.

27. Heart with Canal: Birmingham's famous canals were always important to the Quarter in the past, transporting fuel and metals into the area.

28. Stamp Letter: Newhall Street was always the centre of Birmingham's communications.

29. Telephone Receiver: in the shadow of Birmingham's famous telephone tower.

With more pedestrian traffic generally, security became a bigger issue with an increasing mix of residents, more visitors and more places to eat and drink. This was highlighted when St Paul's Square was the scene of a late night murder.

This was obviously not the sort of publicity that we wanted and added to the pressure from jewellery-based businesses who, not unreasonably, were concerned with the increasing number of people living in the area and consequential increase in restaurants and bars. This, of course, inevitably increased late night pedestrian traffic when the jewellers were closed and, in their eyes, made their premises more vulnerable.

Celebrating the Crown & Anchor, the pub where Birmingham ended up with their famous anchor assay mark after the toss of a coin.

Newhall Street, once the site of the 'Russian Mountains' rollercoaster.

Celluloid was another invention by Elkington's, once in Newhall Street. Hollywood owes it to Birmingham?

However, there were two issues to be tackled in installing a comprehensive CCTV system, which is what everybody wanted to see. This was raising both the capital and revenue cost and, as is often the case in regeneration, securing the capital costs was the easier ask. We put together a package involving Section 106 planning gain and some matched funding from Advantage West Midlands, the Regional Development Agency who proved a very supportive partner in regenerating the area.

With no significant budget from a hard-pressed local authority, this was typical of the cocktail of public sector support. Funding usually came from two out of three main sources: planning gain, the Regional Development Agency and European Funding. At that time, the CCTV across the city centre was run by a mainly local authority and police-backed initiative called Citywatch with a monitoring base in Lancaster Circus in the city centre.

Somehow we managed to persuade them to add the extra Jewellery Quarter cameras at no revenue cost to ourselves. Perhaps the most controversial aspect of the scheme was our aim to have comprehensive signage to deter any perspective criminals. However, there had been a recent court case where a member of the public had successfully sued

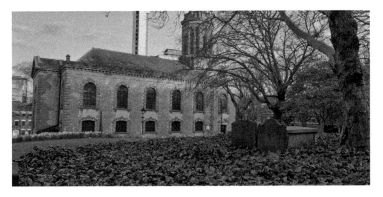

Above: The beautiful church of St Paul's as the day draws to a close.

Right: Remaining evidence of the presence of CCTV, also the City Council's signage strategy!

the authorities because, while there was a CCTV sign displayed, the CCTV hadn't been switched on/monitored at the time of a crime they had experienced.

Another early issue was looking at how we could make routes into the Quarter from the city centre more welcoming. As part of this, one of the main routes into the Quarter was along Newhall Street. While it included the iconic Assay Office and the Elkington buildings, it was generally a bleak street, fairly stark and a bit of a wind tunnel in inclement weather.

There was initially a debate with the City Council's Conservation Department, whose view was that the area was a 'hard' manufacturing area and trees were inappropriate. We argued that to attract visitors into the area some trees would help soften the scene, making it more user friendly. They were not convinced so we then asked the Conservationists what there was before the Jewellery Quarter, and they grudgingly admitted it was trees! The compromise was that we were allowed to plant a few, which suited us as we were never after a Jewellery Quarter forest.

We sat down with Highways Department to see what could be achieved in terms of some tree planting. We eventually reached an agreement to plant a row of trees either side of the street, which was not as easy as it sounds. We found that, with a preponderance of telecommunications and post office buildings, beneath the pavements was a maze of statutory utility infrastructure and tunnels that limited the number of trees we could plant.

The other complication was that the costs weren't just the cost of the trees and the planting itself, but maintenance over twenty-five years. However, with the help of Section 106, we got a result and the trees definitely helped 'soften' the street scene on this main route into the Quarter.

This emphasised the importance of the committee we had formed, made up of both business and residential representation, to not only comment on planning applications in the Jewellery Quarter but also to agree a list of priorities for the use of Section 106 planning gain – this was a critical factor in funding. Given the rationale that this money was, and is, supposed to be for community benefit, it made sense to me that it should be the community who should be the major influencers rather than the local authority.

Trees in Newhall Street aimed at making connecting routes more user friendly.

CHAPTER 4

Putting in
The Building Blocks

When people think of a village or self-contained community, health, policing/security, shopping, schooling, a post office, and recreation and community meeting places all spring to mind alongside employment opportunities. An audit of the area would have shown that apart from a police station and post office there was little else in place other than, of course, opportunities for employment in the jewellery trade.

On the shopping front, there was a wide choice of small independents that provided an excellent selection, but only if you wanted to buy some jewellery. In terms of the food offer there were a couple of small independent convenience stores, so we immediately set out about trying to tempt in one of the major supermarket chains. My dreams of a Waitrose were just that, but at least Tesco showed an interest.

Strangely, they agreed to look at a presence in the Quarter but only on the basis of the potential of shoppers from the existing residential population. Bizarrely, they were initially reluctant to consider supermarket viability based on the not inconsiderable numbers of businesses and presumably hungry employees. In fact, in final analysis, we ended up with the two Tesco Metro stores.

At that time, there were also a number of small cafes where there was no problem getting a bacon butty or a pork bap but where a request for a cappuccino and croissant would have been met by raised eyebrows. Entrepreneurship being what it is, we ended up with several independent cafes where a leisure visitor (or resident) could buy a decent cup of coffee and piece of cake.

Interestingly there was no sign of interest from a Starbucks or Costa, which we were quite comfortable with on the basis that the Quarter was a quirky and unique area with mainly independently owned businesses. Undoubtedly, the planners helped to achieve this result with their carefully crafted planning guidance.

We then looked at health facilities, of which the area was devoid apart from a couple of private dentists and physios. While no expert in the NHS, I found which local health authority office covered the area. I then knocked on the slightly decrepit door of their area office and was given a shortlist of GP practices in the area.

Luckily for me, my first port of call was to a doctor who was operating out of cramped and patently unsuitable accommodation just outside the Jewellery Quarter and who,

Coffee anyone?
A plethora of
independents
and not a greasy
bacon sandwich
in sight.

having heard about the Urban Village, fancied a move into the area with the aim of brand new customised premises and an expanded clientele.

I took him around for a tour with a local developer, David Keay. David was a rarity as a developer in that he had a social conscience, pride in achieving quality and a real love for the area. We chose a car park area at the bottom of Warstone Lane and after a fairly lengthy battle to secure a public sector funding package to match private sector funds, we ended up with a state of the art health centre. As a bonus, the facility included a pharmacy to serve both the growing Urban Village community and surrounding areas.

David Keay was a real force for good in the Quarter, as was his development partner, a likeable guy called Gerry Pountney. Another example of their work was the refurbishment of a semi-derelict building opposite the Jewellery Quarter Station. This was owned by Birmingham City Council and their Property Services people guarded their properties and the subsequent income like the crown jewels. However, because this building had a railway line running underneath and therefore no proper foundations, they reluctantly had to almost give it away. Dave and Gerry then cleverly refurbished it with an innovative steel structure underpinning the building and it was turned into a restaurant, the Forge – sadly now closed with the owner moving to more rural climes.

Green space was always going to be a problem with premium land prices, so plans were put in place to improve the rundown cemeteries and St Paul's Square. Other plans included an opportunity to create a 'Golden Square' to replace a large car park serving the Big Peg, a somewhat undistinguished high-rise building by the Jewellery Quarter clock.

All the time these plans were being moved forward, a battle was raging as speculative developers bought sites and buildings in the hope of refurbishment or better still (in their eyes) knocking down old industrial buildings and replacing them with new residential developments. This also led to many buildings being bought speculatively and being left to rot (or in one case actually fall down) in the hope that planning restrictions on residential use would disappear over time. Alternatively, it was seen as a shrewd investment to be sold on as land prices heated up.

The Forge,
a quality
refurbishment
and an
engineering feat.

The Big Peg
car park, a
soulless centre
to the Quarter.
Thankfully
no more.

Luckily, there were safeguards in place in the shape of the Conservation Management Plan (CMP), which had been also been subsequently adopted as supplementary planning guidance. This divided up the area into eight different zones – City Fringe, St Paul's and Canal Corridor, the Industrial Middle, the Golden Triangle, South West Industrial Fringe, the Cemeteries and Great Hampton Street and Viaduct.

The most controversial was the Golden Triangle, where residential development was not generally allowed, and the Industrial Middle, where there were also constraints on residential developments but to a lesser extent. The CMP stated quite clearly,

The dominant development trend in the Jewellery Quarter in recent years has been a provision of new residential accommodation ... Residential development has not only resulted in loss or change of use of industrial buildings but does significantly enhance property values. This latter factor threatens the continued industrial use of manufactured premises and reduces the amount of workspace available to traditional industry in the Quarter. The density and integrity of surviving industrial premises within the locality of the Golden Triangle and the Industrial Middle makes a powerful contribution to the character of the Jewellery Quarter such that it is considered inappropriate to permit any change of use of industrial or commercial premises to residential use.

Wise words indeed!

This, of course, caused an outcry from estate agents, land bankers and property speculators who thought they had the golden ticket, putting forward the naive argument that the Jewellery Quarter started out many years ago with residential properties with subsequent conversions to workshops as the Jewellery Quarter gathered pace as the place where jewellery and allied products were made.

There were loopholes within the Conservation Management Plan stating that the Planning Authority would consider mixed use within the Golden Triangle and Industrial Middle where it could be shown to support the development of small-scale light industrial and commercial space.

The Council planners also put in an exception for the often spurious concept of live/work where the ratio of living to working space did not exceed 50 per cent. This was often spurious because of the grey area of identifying common space like kitchen and washing facilities and the fact that many creative industries in a digital age didn't need or want rigid spaces. Enforcement was also an issue given the paucity of resources in the City's planning department.

All this was overlaid with the difficulties of obtaining a mortgage on a live/work property. To this day, the comparatively low number of live/work developments have tended to slip organically into either live/live or work/work, which is probably not surprising given all these difficulties.

This is perhaps best illustrated in Hylton Street in the Quarter, where one large live/work development is basically almost all commercial and the one adjacent (the Spectacle Works) is now mainly residential. The building is managed by a Housing Association who did their financial calculations on the basis that microbusiness would be able to afford commercial rents on both a live and a work area – a supposition that proved less than fully accurate in practice.

In 2005, somewhat belatedly, a Jewellery Quarter Conservation Area Design Guide was introduced with the backing of English Heritage. Suffice to say that it covered everything in detail from 'disliking' Juliette balconies and other clutter to encouraging the reinstatement of front plots. In fairness, it generally did a decent job in protecting the integrity of the Quarter and the style of development but in some cases the architectural horse had already bolted on some abysmal developments.

The Spectacle Works, one of the more successful live/work developments.

Perhaps one of the examples of this can be seen in one horrific development fronting Warstone Lane, with an even more brutal rear view. The City Council Conservation Department allowing it through still defies belief. It has also become clear that some of the supposed quality development allowed by the Council planners has resulted in other problems such as the use of dangerous exterior cladding and other issues.

Similarly, the City Council insisted on ground floor retail in what was otherwise a decent residential conversion of a redundant factory in Great Hampton Street. Again, it beggars belief that the City Council Planners could envisage somebody investing in massive units on what must be the scruffiest and most rundown main street into the city centre. It became the very epitome of an architectural white elephant.

A major problem was land banking, where developers (or even jewellers wanting a retirement plan) bought buildings even when there seemed no hope of getting planning permission for residential development. In some cases it has to be said that many of these buildings were allowed to go towards rack and ruin based on the philosophy that if they fell down, they would be easier to develop.

This was compounded by the lack of resources that the local authority had to deliver any proper enforcement in the shape of Compulsory Purchase Orders (CPO). Luckily in some cases the mere threat was enough to deliver a satisfactory solution. The Ferridax building (near the Jewellery Quarter clock) and the George & Dragon pub (now the Pig & Tail) on the corner of Albion Street were two examples of derelict buildings being saved and restored.

Of course it wasn't always the private sector involved and a major player in land banking was the College of Food and Tourism. They were rebranded University College Birmingham (UCB) and had an impressive portfolio of land that included sites which lay derelict for years. One, a redundant nurses hostel in Ludgate Hill, was seen by many observers as a strategic acquisition on the basis that it would be prime land when a large car park opposite was developed.

Yet many years later, the hostel still remained vacant and derelict, although we did commission some public art to make this gateway site a little more interesting. Equally

Heritage Court, not exactly a feather in the cap of the Council's planning department.

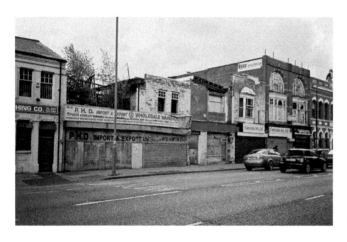

Dereliction in Great Hampton Street.

'Ghost' retail. Mixed use or no use?

The George & Dragon
before refurbishment,
immortalised by local author
Kathleen Dayus.

The Pig & Tail, once
the George & Dragon in
Albion Street.

Kathleen Dayus artwork, celebrating one of the Quarter's
most famous authors.

Ferridax building in Frederick Street, one of the many fine buildings in the Quarter that were allowed to run to dereliction before being rescued.

Ferridax, now restored to its former glory.

Nurses Hostel in Ludgate Hill, owned by the university. Derelict and an eyesore for many years, but brightened up with public art.

the UCB stubbornly held on to a larger site in Legge Lane mainly due to the City Council's insistence that some of the old façade had to be preserved. Development eventually started but only after many years of dereliction. However, in fairness to the UCB, they also undertook a lot of new development in the area, expanding their campus whilst bringing life to semi-derelict side streets and thereby bringing some tangible benefit in terms of the life of the Quarter.

Design issues still remain a matter of opinion and emphasis and although there has been the *Design Guide* (at the time of the writing soon to be reviewed), it was not completely definitive or particularly helpful in some of its advice. For example, we felt that good quality pastiche was preferable any time over something new but bland and mediocre. An example where a pastiche type of approach has worked well is the St Paul's Place development fronting St Paul's Square. This fits in very nicely in an architectural way to Birmingham's last remaining Georgian Square.

On the topic of St Paul's Square, some strange planting underlined the problems around the lack of joined up thinking between council departments, something that we were always wrestling with in getting things done. The City Council Conservation Department were always quite rightly protective of Birmingham's last Georgian Square. However, unbeknown to them the Council's Parks department decided that beds of trendy exotic plants should be a new theme one year. Hardly Georgian but, in fairness, it did us no harm with our 'In Bloom' initiative that year, even if the Conservation officers were horrified by this horticultural intrusion.

To further highlight this type of problem, underneath lengths of the churchyard paths were underground graves so the continual passage of the City Council Recreation and Communities department's heavy machinery to tend the churchyard had inevitably caused major damage to paths, much to the chagrin of the City Council's Conservation Department.

I suppose good design can be in the eyes of the beholder but sometimes we despaired at the decisions of the planners and their committees. A case in point was a junction of four roads

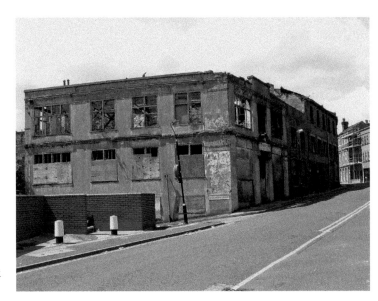

Building in Legge Lane, another eyesore allowed to fester for many years due to lack of enforcement.

41

St Paul's Place, an example of how pastiche, much maligned by planning purists, can comfortably fit in to an historic area.

Tropical planting in St Paul's Square. An interesting concept for Birmingham's last remaining Georgian square!

(at the end of Albion Street), which had become a bit of a *Keystone Cops* scenario in terms of the traffic. It called out desperately for a proper roundabout but instead the supposed sophisticated alternative of raising paving to slow traffic has led to complete confusion as nobody seems to know who has the right of way in the area known as Dayus Square.

There is, of course, a time when more intervention would be welcome, for example the plethora of seagulls in the Quarter. These days, it appears that seagulls seem to prefer an urban environment to being beside the seaside.

Unfortunately as some gulls are a protected species, culling isn't an option so other measures have been tried. For example keen observers walking around the Quarter and looking upwards will sometimes see a dummy sparrow hawk. Other measures include replacing eggs with a dummy version, which is both time-consuming and expensive. The most sensible and long-term solution would be to design measures on roof construction to make buildings unattractive for roosting and write this into the planning conditions. This does not really appear to have happened to any real degree.

Dayus Square in Albion Street, a highway's department's dream but a driver's nightmare.

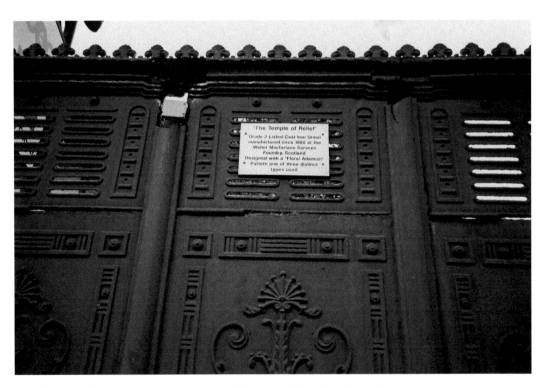

The Jewellery Quarter's controversial 'Temple of Relief' in Vyse Street.

In fairness, we generally rubbed along with both the Planners and Conservation officials, who were passionate, if sometimes over purist, about their job but always with the best intentions of safeguarding the integrity of the Quarter.

The nearest we came to falling out was over some Victorian cast-iron urinals. These were, and still are, located by the Jewellery Quarter station and had been a long-standing problem because the plumbing had long fallen into disrepair but were used as an urgent relief stop by passing bus drivers. This meant that during the summer months it became a real nuisance and not a place to take in the airs.

We worked with the Planners to identify some planning gain money to design an iron lockable gate to the entrance. All good, until we fell out over a plaque to give some narrative to its history. Having done our research we put forward some wording which included a Victorian nickname for this type of urinals dubbed as 'Temples of Relief', which we thought might bring a smile to passing visitors.

This triggered a shock reaction from the Conservationists, fearful that the use of the word 'Temple' in this context might upset members of the religious fraternity. We ignored the comments and erected a plaque with all wording intact and, perhaps unsurprisingly, to my knowledge there was not a single subsequent complaint. It's worth mentioning that it took us eighteen months and the exchange of exactly ninety-five emails to achieve a result, but we were determined not to be beaten!

Other ideas put forward by the Planners included the concept of green roofs, which was a great idea in theory but has sadly only resulted in a couple in the Quarter. An opportunity missed.

The Hive Herb Garden, unfortunately one of the few roof gardens in the Quarter.

CHAPTER 5

The Jewellery Trade (A Trade Worth Keeping)

Perhaps the biggest talking point when the Urban Village initiative was announced was the concern that a steep rise in land values would be a death nell for the many jewellers working in small, cramped but cheap premises.

Obviously the Conservation Management Plan sought to prevent this happening by barring or drastically limiting the potential for residential development where the majority of jewellers still operated. A plan which, of course, was universally hated by anybody wanting to make a quick buck from property sales.

In fairness to the Urban Village Plan, it was launched when the jewellery trade, like all manufacturing, was contracting. While one or two businesses still made a living assembling jewellery components made abroad, the days of competing with cheap labour countries like Turkey, India and China were long gone when it came to manufacturing 9 carat catalogue jewellery, described by many a quality jeweller as gold paint!

Yet the Jewellery Quarter still made an estimated 40 per cent of UK-made jewellery. A figure that we roughly calculated by totalling all assaying in the UK after making an allowance for jewellery made abroad and comparing Birmingham with the rest of the country. The trade's makeup is an interesting one, spanning designer makers, expert craftsmen from polishers to engravers, and larger firms with a full range of skilled personnel.

Many of the designer makers come out of the School of Jewellery (reputably still Europe's largest) but not all are multi-skilled. Many of them tend to be very talented at design, concentrating on one-offs, but their living is often a precarious one unless subsidised by a partner.

There are larger firms like Toye, Kenning & Spencer, Fattorini, and Weston Beamor, who are large enough to indulge in apprenticeships and can afford to train up their own people. Nevertheless this is a delicate balance to maintain and our Partnership tried to do this through supporting several initiatives to encourage both new jewellery businesses and craftsmen/women.

Firstly there was a scheme called Design Space, the brainchild of a forward-thinking Brummie, Peter Taylor, who went to work for the Goldsmith's Company, based in London but still a great advocate for Birmingham's jewellery trade. This very successful scheme was backed by the City Council Economic Development Unit, Central Government and Europe.

School of Jewellery, in Vittoria Street, claimed by many to be the largest school of jewellery in Europe.

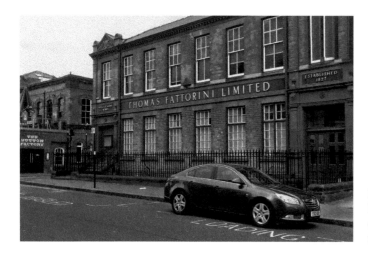

Fattorini, a long-established and the company that once made the FA Cup.

It was aimed at giving newly qualified jewellers or silversmiths a taste of business within a sheltered environment before they went fully commercial. Pricing, marketing and exhibition experience were all part of a support package and there are a substantial number of jewellers today in the Quarter who came through that enterprise academy.

There was also an annual festival for designer makers called Brilliantly Birmingham, which was an event with open workshops that highlighted and showcased some of the many excellent young (and not so young) designer makers. Alongside this was an initiative called Design Gap. This was an independent and privately funded initiative all due to the hard work and commitment of a lady called Shirley Frost, who developed a marketing network on the back of a Designer Maker directory/catalogue.

Perhaps the most difficult nut to crack was apprenticeships because the new government version was a funding model confined to funding some college time, but unlike traditional old style apprenticeships it did not provide funding for a wage subsidy.

The major problem with this was that it took some time to let somebody loose, however dexterous, on valuable/precious metals. At the same time this would be taking a skilled craftsman off the bench to teach that person, which compounded the negative economic impact for a business.

Of course, it is an expensive and time-consuming process to train employees up to the necessary skill level even for bigger firms – and certainly out of reach for the ageing micro firms that still play an important part in underpinning the viability of the jewellery trade in Birmingham.

Luckily there was some help in the form of the Goldsmiths Company and Peter Taylor, who had masterminded Design Space and had moved to London but never forgot his roots. As a result he masterminded the concept of an apprenticeship scheme that included a wage subsidy to make the whole proposal more viable to businesses.

The School of Jewellery, anxious to keep pace with new technology and more importantly to train students on leading-edge equipment, also invested heavily on a Jewellery Industry Innovation Centre with strong support from the Regional Development Agency and Europe. The idea was for the whole project to become self-financing by eventually being used commercially by local Jewellery Quarter manufacturers, although the jury is perhaps out whether this was ever fully achieved.

Incidentally, the School building itself won a top design award in 1992 for its extension on Vittoria Street, which was designed by Jewellery Quarter-based Associated Architects with a customised interior that at first sight looks like the inside of a prison with all its walkways. However, this design was to ensure that there was not only plenty of natural light but that there was freedom of movement and vision as young students were involved in processes that could easily cause an accident or injury. The last thing that anybody wanted, from a health and safety point of view, were classrooms that were hidden away.

Despite supportive initiatives, the jewellery trade faced many other challenges, not least the dilution of a mainly manufacturing area into the mixed use Urban Village with more competition for parking, fears of more crime and the heating up of property prices with landlords keen to maximise their returns.

Another threat was the increasing amount of jewellery made abroad, where labour and raw materials are often cheaper. You could break the Birmingham jewellery trade down into four main segments – large manufacturers, retailers (some with workshops out the back or above), designer makers, and specialists from polishers to stone setters. These specialists were often called jobbing jewellers.

The latter group are now generally an ageing population, anything from their mid-forties (the youngsters!) to their late seventies. This obviously means that they are most at risk of dying out. Yet they still underpin a lot of what goes on in the Quarter.

The large manufacturers are generally the only ones equipped to bring on specialists craftsmen for mass/volume manufacturing. This is because they have the capacity and infrastructure to take on apprentices.

Most of the designer makers gravitate from the School of Jewellery and either join a large manufacturer or start their own business. The latter can be a tenuous route but often they survive by sharing workshops or being subsidised by a partner.

There is a number of initiatives for them to showcase their products. Centrepiece, a consortium of high end designer makers, held a Christmas show among other showcasing

opportunities. It is also worth noting that there is a slight degree of uncreative tension between the young freshers and the ageing time-served specialist craftsmen in the Quarter. As one of the latter said disparagingly to me, 'If you want somebody to make a chain mail helmet with a diamond on top go to them, but don't come to me!' A jibe at what many of the older jewellers saw as the wacky designing and making of obscure, uncommercial one-offs.

Lastly there are retailers. who are comparative latecomers to what was mainly a manufacturing area. However, they have more than made up for it with an estimated 100 independent jewellery outlets, most of them family run. This choice can become almost overwhelming for the visitor and we always used to tell visitors intent on buying jewellery to try two or three retailers before deciding on a purchase. A strategy I still suggest today if asked for advice on buying jewellery.

Interestingly, very few of the retailers have graduated through the School of Jewellery, although there are some outlets like the long-established Artfull Expression where designer maker jewellery displays are attractively and conveniently grouped together.

However, one of the few that have made it as a solo retailer is James Newman. I asked James why so few designer makers end up running a successful retail outlet and he felt that the pressures of running a retail business, ranging from accounting to managing all of the overheads, contributed to that paucity.

James, originally from Yorkshire, came to Birmingham to study after considering other alternatives including Sheffield and Loughborough, with London only fleetingly in the frame partly because of the distance. Both the attractions of a newly refurbished Birmingham School of Jewellery and the local opportunities in an area like the Quarter played a big part in James' decision.

I asked James about the added value of having a shop that people could visit and he felt it was because when people commissioned jewellery, being part of that design process also became part of the story of buying something special, usually for a significant event.

Birmingham Assay Office, the original building in Newhall Street before they moved to Moreton Street.

Centrepiece, a consortium of talented contemporary jewellers based in the Quarter.

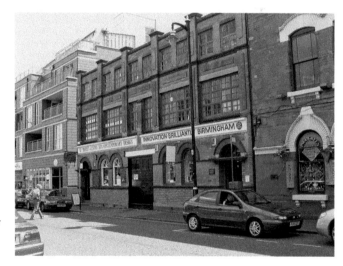

Artfull Expression, in Warstone Lane, a place to buy stunning unique jewellery made in the Quarter.

Crystalink, in Hall Street, a typical long-established independent family jeweller.

While James had some customers who actually live in the Quarter, most travelled from all parts of the country. This means the more the Jewellery Quarter improves its all round offer, with its museums, restaurants and historic street scene, the more attractive it became to visit and buy jewellery. On the topic of infrastructure improvement, he felt that some traffic calming allied with the environmental improvements already underway in the area, such as improving the historic cemeteries, would help create a relaxed and more conducive atmosphere for visitors.

We talked about the shortage of skills and James had tried to combat this by bringing work in-house. However, with a small staff, this left little room for manoeuvre – not least because training new staff to a finely honed level was expensive yet vital bearing in mind James' high end market. Finally, I asked him about the future. He felt that though the regeneration of the Quarter was generally a good thing, the concern had to be that many businesses were in City Council-owned property and the temptation for a cash-strapped Council to maximise profits on their portfolio might thereby destabilise those small businesses.

Successful jeweller James Newman at work in his rear workshop.

James Newman's shop front in Vyse Street... plain, simple and classy.

One of the tragedies for the Quarter's craftsmen and women is that they make some wonderful products, in some cases for famous events and people. Too often, it is usually a London-based firm who take the credit by commissioning Birmingham firms to make products. Part of the deal is then that the Birmingham firms are sworn to secrecy, enabling the commissioning firm to pass off the product as their own. Examples of famous products made in the Quarter include the Queen's Birthday Honours, the FA Cup, and the Golden Boot. On a slightly more modest scale, celebrities like Ozzy Osbourne, Prince Charles and Elton John have commissioned bespoke pieces.

I spoke to Neil Grant, a man in his sixties who owns Crescent Silver in Spencer Street. Neil, who incidentally looks a little bit like a younger version of rock star Neil Young, started work as a self-taught engraver thanks to his father. His dad originally managed Cavalier Tableware, who were based in the Quarter. He told me that his first job was an engraving commission for Avon and prior to that he had just had a week's training on an engraving machine – which he still has over forty years later!

After a brief spell operating out in the sticks in the rural shires, he moved back into the Quarter and bought the building that now houses Crescent Silver and other jewellery-related concerns. He has undertaken a host of commissions for famous people and organisations, from the world of sport to luxury car manufacturers.

Unfortunately, like most of the Quarter's skilled craftsmen, he cannot reveal who most of these are without losing contracts. He did, however, tell me that he made gifts for the Highgrove shop and had met Prince Charles. Neil was in fact the silversmith who had made the silver candlesticks for Elton John's wedding and, on the topic of musicians, he had even made silver crucifixes for Black Sabbath's Tony Iommi.

Above left: Crescent Silver, in Spencer Street. One of the few surviving quality silversmiths left in the Quarter.

Above right: Neil Grant, owner of Crescent Silver, showing his colours and one of the many trophies for which he gets commissioned.

However, Neil, no spring chicken himself in terms of age, also works with a fairly ageing team and he told me that in his opinion retail silverware in the Quarter was dying and was only really kept alive with bespoke commissions and awards. In addition, christenings and weddings still provided some source of income. Repair and restoration were still sometimes in demand but generally silverware had gone out of fashion.

Yet Neil still feels passionately about the trade and his creative mind is still full of ideas and adaptations to fire the imagination of customers. However reluctantly, he told me that he was moving away from retail and building up an online presence.

Neil's pride in the Jewellery Quarter was exemplified by his involvement in the locally led campaign to safeguard the authenticity and integrity of Birmingham's famous Assaying anchor mark, ensuring that when Birmingham Assay Office opened its branch in Mumbai, they should not be allowed to use Birmingham's unique anchor mark.

This campaign in 2016 was on the basis that it could give the impression to customers that the hallmarked products had been made in Birmingham when in fact they had been made in India. This successful campaign was spearheaded by another manufacturer, Millingtons, who co-ordinated it under the banner of the British Hallmarking Protection Alliance. Those involved contributed to fund a QC. As Neil said to me, it was money well spent for the Jewellery Quarter, even if the Assay Office was probably not best pleased.

In fact, there is a view that Birmingham has over the years been stitched up a few times and there are a couple of examples that appear to support that theory.

At one stage Birmingham had a highly profitable and thriving mint making coins, but lost out on a contract, in my view due to Government politics and London bias, to the London Mint. This was one of the main reasons that led to the closure of a once thriving Birmingham operation.

Once the famous Birmingham Mint, with its iconic tower preserved as part of a large residential development.

The mint's iconic tower kept as part of the development.

More recently, when the Olympic Games were held in London, several of the major manufacturers in the Quarter formed a consortium to bid for the highly lucrative contract to make the pin badges that are given to all athletes and officials. Despite undoubtedly having the capacity to deliver economically, they lost out to a supposed London first that was, apparently in fact, just a front for a Chinese manufacturer. Interestingly, it was rumoured that one of the firm's advisors was a top official on the Olympic Committee.

Despite all this, the manufacturing base of the Jewellery Quarter survives and while it has contracted, this has been no more dramatic than elsewhere, despite the threat of escalating residential land values, overseas competition and a generally ageing workforce. There is also the issue of crime with a mixed use area, and while the incidents of drug taking and beggars are no worse than other areas of the city, it is a concern to many jewellers – particularly since the area's local police station closed.

The importance of this was perhaps best illustrated when in 2008, as a result of a death in police custody, some gangs went on a rampage looting city centre shops. Predictably, they also marched on the Jewellery Quarter, but were scared off by the sight of a police van appearing. Little did they know that the Jewellery Quarter police station and its accompanying van were manned by the only two policemen on duty.

Unfortunately, that deterrent is gone, as has the frequent sight of old 'Bendy Legs' (a well-known jewellery courier) walking innocuously through the Quarter with a couple of carrier bags full of valuables. This type of courier is predictably fast disappearing as crime becomes more sophisticated.

Of course, the manufacturing base is not just about jewellery and there are some excellent businesses making a range of products. BDG, a firm in Northwood Street, make top of the range cutlery for cruise ships. An interesting example of non-jewellery manufacturing in the Quarter was A.E. Harris, though they have since moved elsewhere. Typically, their site was bought by a developer, who secured a somewhat controversial piece of planning permission.

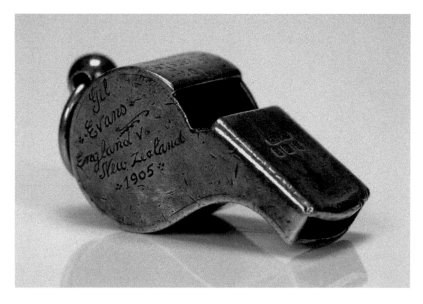

The Acme Rugby Whistle, a piece of sporting history from 1905.

Originally A.E. Harris made parts for Leyland alongside a host of other Birmingham firms, but when the car giant folded the firm turned their skills to making coach seats. This was highly successful and they even provided the seats for the rocket ship in the sci-fi film *Prometheus*.

Perhaps the most famous manufacturer outside the jewellery trade is Acme Whistles, home of the world-famous referee's whistle, the Acme Thunderer, and also maker of the *Titanic* whistles. Simon Topman, the enigmatic managing director of this family firm, even has a private whistle museum. Simon has continued to be a real champion for

The iconic Acme Thunderer still standing the test of time, and something VAR can never replace.

Simon Topman, MD of Acme Whistles and a great defender of the Jewellery Quarter and manufacturing generally.

manufacturing and the longevity at the firm is testimony to his expertise and commitment to the sector. The business has been based in the Quarter for over 150 years and Simon has been involved for more than forty.

I asked him about their use of craftsmen in the Quarter over the years, with Acme needing workers capable of plating, polishing, hand engraving, and even gem setting for the 'must-have' whistle. Unfortunately many of the people with these skills are ageing well past the normal retirement age and already Simon has had to go far afield for some of these skills. One of the problems is the lack of successful apprenticeship schemes. In Simon's view, these aren't helped by the bureaucracy that surrounds such schemes.

I asked him about his main method of recruitment and quite often this simply stems from somebody who wants to change employers to better themselves. Direct recruitment from job centres and schools seems to be the exception rather than the rule. Acme have a very diverse workforce with around twenty different languages spoken.

In terms of supporting and building a decent manufacturing base, Simon thought that maybe the one positive fallout from the COVID-19 pandemic might be for the government to start encouraging and supporting manufacturing businesses while supporting and encouraging recruitment. The initial reliance on other countries to produce items during the pandemic became an embarrassment with issues of quality control compounding the supply problems.

On the topic of the pandemic, Simon mentioned the increase in internet sales, given the lockdown, and he felt that this could become a major trend bringing with it a demand for bespoke one-off items. Already 85 per cent of Acme's sales are from abroad and while this predictably includes the USA as a major customer, it also includes China with an increasingly brand conscious buying public.

Simon has a wealth of great stories but the one I liked best was about a group of apprentices playing football in the 1900s in the Jewellery Quarter's Vyse Street.

The tale goes that at lunchtime they decided to have a kick around but somebody said if it was to be properly organised they would need a whistle and a referee. So somebody went along the street to visit Acme Whistle, but was fobbed off with what was actually a policeman's not a referee's whistle. As a result when the first foul was committed somebody blew the whistle and out of a nearby derelict building rushed what was apparently a band of burglars, who had been tunnelling in the derelict building to try and access the bullion dealers next door!

I asked Simon about the most memorable whistle that they had made and he recalled a gold whistle that had been commissioned many years ago. This had been supplied for Humphrey Bogart's funeral, to be buried with him at Lauren Bacall's request. This was to celebrate the immortal line in *To Have and Have Not*, when Lauren Bacall says the memorable words 'If you need me just whistle'.

I then spoke to Greg Fattorini of Fattorini's. This famous firm of badge and medal makers is one of the Quarter's larger and most well-known businesses.

Fattorini are actually a Yorkshire family firm that moved into the Quarter almost a hundred years ago. Brisk business had meant they needed to increase their quality control and having their own manufacturing facility made sense, ensuring the top quality products for which they were known.

I asked Greg about competition from abroad and particularly the Far East but this seemed to be less of a threat than one might think, given Fattorini's ability to produce bespoke items and small batches in tight timescales while ensuring quality. This was always likely to remain a unique selling point which overseas competition found hard to beat.

Our chat turned to the Urban Village and the threats that it posed to many factories in the Jewellery Quarter. While the Conservation Management Plan was seen as a good thing, Greg felt that the resource position at the City Council meant that some residential planning of debatable quality had slipped through. Not only did this residential development threaten manufacturing due to incompatibility of location, it also encouraged even more developers to push the boundaries further and further. These developers were often from out of town and were often only interested in the bottom line profit with no feel for the Jewellery Quarter and its unique history and place in the city.

All this meant that land prices heated up and often it was enough to push out smaller craft-based businesses who had been operating for years in the Quarter. As a note of hope and positivity, he did feel that the Jewellery Quarter Development Trust had recognised the issue and were trying to tackle the problem.

Finally I asked him about skill shortages and he felt that there was not enough encouragement for young people to pursue a vocational path. This was exacerbated by the current apprenticeship model, which he felt was not particularly fit for purpose in either its structure or its funding.

CHAPTER 6

Shining A Light on The Gem

While Birmingham is the UK's second city, cosmopolitan and multicultural, it is a strange phenomenon that, to many residents, the centre of Birmingham might as well be split by a virtual Berlin wall with the north and south of the city residents sticking to their own patch.

This means that there is still a major task to ensure that residents from all over Birmingham start to recognise and enjoy the unique area that is the Jewellery Quarter. The continued expansion of the tram network will be an important element in making this happen.

Much as it hurts me to say it, outsiders who have never been to Birmingham still see us as a community of 'Barry the Boring Brummie' living in a rather dark, metal-bashing scenario. In fact, I will never forget meeting an apparently experienced and well travelled reporter from the *Daily Telegraph*, who had been sent to do an article on assaying, who confessed, as a London-based journalist, that he had never been to the city before.

While there is a website called Visit Birmingham run by the local tourism body, the West Midlands Growth Company (WMGC), the organisation is more and more income led and therefore has to be seen to look after its commercial members who pay an annual membership fee. It has also received funding from the EU, which has meant that it has had to focus on investment outputs to help safeguard its income. This consequently means that in my opinion tourism priorities have slipped some way down the agenda, particularly in terms of the city's heritage.

Of course, Birmingham has the Bull Ring (once allegedly the second largest shopping mall in Europe) and Grand Central shopping malls, but there must be a concern that this becomes the Birmingham tourism headline rather than the far more interesting and unique areas such as the Jewellery Quarter, Digbeth, the Balti Triangle and suburbs like Harborne, Handsworth, Edgbaston and Moseley.

Obviously, the funding raised by the Jewellery Quarter Marketing Initiative was critical in making sure that we never really lost out in marketing to the growing number of Business Improvement Districts but the simple fact was that we were not competing on a level playing field with other areas. This was despite the fact (and you'll have to excuse the bias!) that the Quarter has probably the richest heritage in the city.

To help combat this, the Jewellery Quarter Regeneration Partnership funders (a mix of the local authority and the Regional Development Agency) agreed to match the funding of the Marketing Initiative pound for pound.

One of the first actions was when Anna Gibson who led the Marketing Initiative decided to publish a first ever Jewellery Quarter Visitor Guide. It was to be a free publication with details on shops, restaurants, bars and attractions and was extremely successful in raising the profile of the area. It was actually achieved at a low cost as Anna herself was a professional photographer and publications designer, while I wrote and researched the text – our typical pragmatic and cost effective approach. Allied to this were various campaigns devised by Anna utilising poster sites and initiatives creatively designed to make the most of days like Valentine's, Mother's Day, and Christmas where it was hoped that people's thoughts might hopefully turn to jewellery, together with school holidays when parents were looking for places to take their families.

Events to attract in visitors included a summer festival. Our hearts were in our mouths with the eccentricities of British weather, which can always make or break an outdoor event irrespective of any contingency plans. To maximise money and exposure we tied this in with the Birmingham Jazz Festival.

Perhaps a highlight of one of the first festivals that we organised was in 2007, which heralded the visit of jazz legend George Melly. He turned up slightly bizarrely in a dress, tracksuit bottoms and carrying a handbag in which nestled his favourite bottle of whisky. Supported by a band that included fellow jazz icon Digby Fairweather, who eventually became a staunch champion of the Jewellery Quarter, we learned that George was almost stone deaf but you would not have believed it as he turned in a star performance on a sunny afternoon in front of a packed St Paul's Square.

Of course, one of our aims was to ensure that as many places as possible benefitted from the increasing number of visitors. Obviously Christmas was an important part of that strategy, so early on we sat down to design some Christmas lights that would be jewellery

The fourth edition of the popular *Jewellery Quarter Guide*.

Anna Gibson, the Regeneration Partnership's Marketing Director, with leading jazz musician Digby Fairweather, who she persuaded to become an ambassador for the Quarter.

themed. As far as we knew these were unique in the world at large and certainly created a stir. Over the years they have been replaced with new designs coming on-stream, but the unique jewellery theming has been retained.

We managed to get sponsorship for a Christmas tree – with gold-coloured baubles and lights of course – together with a Santa Race, with proceeds going to charity. Keeping that concept fresh was always a problem and a Santa Race became a Santa Sack Race, which in the third year became a Three-Legged Santa Race. It all helped to build a community spirit among businesses.

In the summer, apart from the Summer Festival, we decided to do our own 'Jewellery Quarter in Bloom', which won several awards, including a silver gilt in 2007, although it is now subsumed within the city centre's own initiative. Involving the local primary schools, clearing weeds and litter, tidying up the historic cemeteries – all this helped to make the Quarter a more attractive place. We could not even go ahead with the initiative until the City Council's Conservation Department had reluctantly agreed that temporary flowers would not spoil the 'integrity of an industrial area like the Quarter'. They had also insisted on setting out the colours that we could use.

These were all initiatives to draw visitors to the area and numbers and awareness started to increase. Perhaps predictably, the visitors also included regeneration 'professionals' keen to see how we were tackling issues and our level of success. This was all good in encouraging investment in the Quarter and one of the highlights was a visit from a team from a national organisation called the Academy of Urbanism, who were champions of highlighting and disseminating best practice.

As a result, we were shortlisted with Nottingham's Lace Market Area and Edinburgh's Stockbridge for the category of ' Best Urban Neighbourhood'. At the high-profile event in London we scooped the award, and a nice sideline was they had commissioned well-known poet Ian McMillan to pen a celebratory poem of which a stanza is preserved in the current Golden Square. The poem captured the spirit of the place to an outsider.

The Quarter's unique
Christmass lights.

The annual Santa Race showing
the jewellers were up for anything
to support a good cause.

In bloom, bringing colour and
greenery to soften the area –
much to the annoyance of
the City Council conservation
department.

This place shines. It really shines. Put that in your poem; it shines.
I'm scribbling as fast as I can, but this place is many faceted,
Like a jewel, you mean? Very clever. Don't forget it; it flippin shines.
It's a kind of multi faceted and gleaming and, yes, shining, asset
To a city that's already full to bursting with ideas and places.
Put this in your poem; it's been here for two hundred years
And have I mentioned to you the Big Peg? Not yet but I will, I will
It was a place where jewellers with their gleaming faces?
Yes, if you like, gathered in this City .. am. I making myself clear?
It kind of moves, this place it dances, it shimmies, it's never still.
Shimmers, I like that. That's really helpful, thank you very much.
No, shimmies, mate; it dances, this place really moves and shines.
A bit like a jewel does; thanks, thanks. it sparkles to your touch
The Jewellery Quarter; craft and art and business meet. Sublime!

(© Ian McMillan)

A nice homage to the area. In fact, one major advantage that the Quarter has over the rest of the city is the amount of heritage and history in a comparatively small area. This is reflected in the half a dozen museums and visitor attractions that have their home in the Jewellery Quarter.

A poem in celebration of the Quarter, now inscribed in the Golden Square.

For example, the Museum of the Jewellery Quarter was basically a family-run jewellery manufacturer which closed down *Mary Celeste* style, with tea mugs, packets of biscuits and other more jewellery-related memorabilia left almost as if it was at the end of a working day. The Museum tells a story of the jewellery trade and the Quarter, generally with demonstrations from volunteers working at a jewellers bench.

A little further up the road in Frederick Street is the Pen Museum, opened in 2001 and housed in the Argent Centre, itself once a Victorian pen factory. The museum, the only one of its kind in the country, celebrates the Quarter's important position when Birmingham was the centre of pen nib making and where almost any pen picked up in the world was likely to have been made in Birmingham. With some of the original machinery where visitors can help make a pen nib, the museum even runs calligraphy classes. These are increasing in popularity.

Just down the road in Fleet Street is the Coffin Works. Thanks to the hard work of Birmingham Conservation Trust, funding was raised to save Newman Coffin Furniture Works from disappearing from the street scene and either being demolished or turned into apartments. This unique museum, opened in 2008, still retains its machinery, shroud area and other artefacts. In doing so it celebrates Newman's position as the place where the coffins of the famous, from Winston Churchill to Princess Diana, were embellished with coffin fittings made in the Quarter.

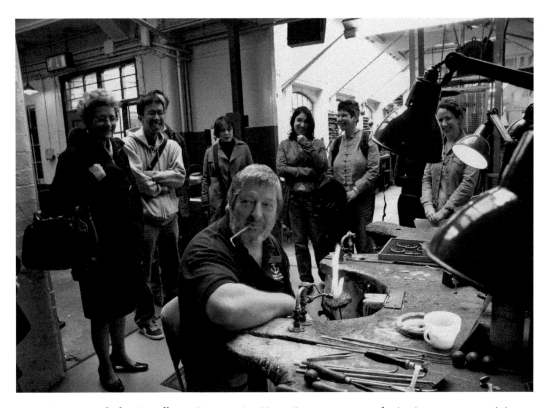

Museum of the Jewellery Quarter, in Vyse Street, an award-winning museum giving a fascinating insight into the trade.

The Pen Museum, in Frederick Street, highlighting the fact that the Quarter was once the world centre for pen making.

The refurbished Hive building – literally a hive of activity.

The Hive is housed in a listed building in Vittoria Street, lovingly restored and used to support people with learning difficulties. It includes an organic café, a rooftop herb garden that supplies the café, and some excellent displays for the public to enjoy. It is also home to a number of excellent craftsmen/women.

Historic cemeteries of the Quarter continue to be improved with heritage monies and have been called Birmingham's equivalent of Westminster, with people buried including Alfred Bird (inventor of eggless custard), Harry Gem (inventor of lawn tennis), John Baskerville (master of type facing), and members of the Chamberlain family, including statesman Joseph Chamberlain.

Coffin Works in Fleet Street. A quirky and fascinating museum set in an old coffin furniture works, seen just after closure.

Coffin Works after refurbishment. It is now an asset to the street scene.

St Paul's remains Birmingham's last Georgian square and, of course, it was where the jewellery trade began before the area was gentrified. The church is a fitting venue for its many fantastic choral events and itself is an attraction. There is even a stained glass window, designed and installed to celebrate the millennium and featuring a map that we had designed in the Quarter for our Jewellery Quarter Visitor Guide.

One of the two Jewellery Quarter cemeteries where many of the city's movers and shakers are now buried.

The tomb of Harry Gem, creator of lawn tennis.

Adding to this rich mix is J.W. Evans, a silversmiths in Albion Street preserved for posterity thanks to English Heritage. Although only open by invite, it is a fascinating insight into a family firm.

Back in St Paul's Square, the Royal Birmingham Society of Artists has found a home for the last twenty-or-so years. It is the second oldest gallery organisation outside London with Royal status and has a large number of members whose superb works of art are displayed (and can be purchased) in its gallery spaces.

Other galleries include St Paul's Gallery, opened in 2003, featuring the world's largest collection of limited edition rock album prints signed by the artists. Finally, there is a host of public art dotted around the Quarter including the pavement trails.

Of course, the Jewellery Quarter isn't just about the history and, with its growing residential population, has a wealth of restaurants and bars from the iconic Rose Villa Tavern to the Lord Clifden on Great Hampton Street, with one of Birmingham's biggest enclosed beer gardens packed full of quirky artefacts. Restaurants abound, including Lasan near St Paul's Square, revered by Gordon Ramsey and winner of TV's 'Best Local Restaurant' competition, and Opheem, a Michelin- starred Asian eatery.

Yet, the shopping offer remains a big draw with over a hundred independent retailers (most of them predictably jewellery-related) and all proudly independent and mostly family run, handed down through generations. A place where visitors can get almost anything jewellery-related.

In terms of green and open space the area boasts both the iconic St Paul's Square and its historic cemeteries of Warstone Lane and Key Hill, nestling side by side. Thanks to a large

The Millennium Window, St Paul's Church, celebrating the Millennium and depicting a map of the Jewellery Quarter.

J.W. Evans in Albion Street is only open sporadically, but allows an insight into a local manufacturer and their family history.

Royal Birmingham Society of Artists, said to be the second oldest independent gallery with Royal status in the country.

Opheems in Summerrow, one of the Quarter's culinary gems and rated by Michelin.

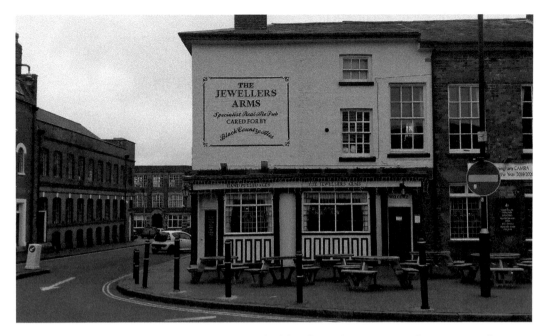

The Jewellers Arms in Spencer Street. Many a deal has been done over an ale or two in this CAMRA-rated pub.

Every day is 'Independents' day in the Quarter with so many small family firms.

lottery grant, both these cemeteries have been improved and they form both a valuable heritage asset and a green lung to the area. Both are lovingly looked after by the Friends of Key Hill and Warstone Lane Cemeteries.

Additionally, near the Jewellery Quarter clock is the aptly named Golden Square, completed in 2014 and once a car park serving the Big Peg – a towering block of workspace where the dream, or should that be a nightmare, was to flatten the Quarter and replace them with modern flatted factories serving the jewellery trade. Thankfully it never happened because when the first (the Big Peg itself) was built, jewellers, who are a fairly private community, did not fancy working all together in a pseudo open-plan environment.

Bizarrely, some members of Birmingham City Council Conservation thought this building had great merit, even though, to most people living and working in the area, it was an architectural carbuncle. Conservation's plaudits were apparently on the basis that it was a unique example of a failed concept.

In fairness, it now serves a useful purpose as workspace for creatives and the new Square has become a focal point for activities including festivals. This conversion from a car park was funded mainly by Europe on some fairly spurious job creation figures and it is a very useful focal point, although, in my opinion, a major opportunity was missed. We campaigned for the installation of some jewellery-related 3D artwork that could act as a photo opportunity – as happened so successfully with the popular bull outside the Bullring. This was a battle were lost with the City Council planners and design teams, who felt the fairly abstract design of the Square itself was strong enough and a sculpture would be too obvious and superfluous. In my view, an example of architectural arrogance to the detriment of the enjoyment of Joe Public.

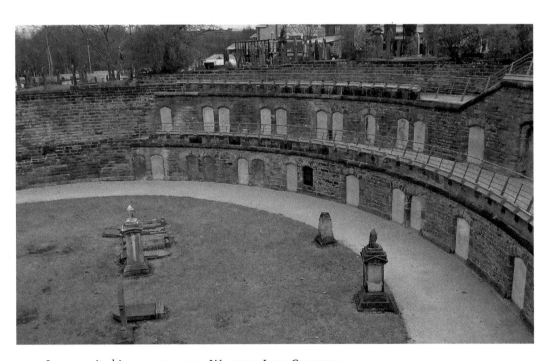

Long-awaited improvements to Warstone Lane Cemetery.

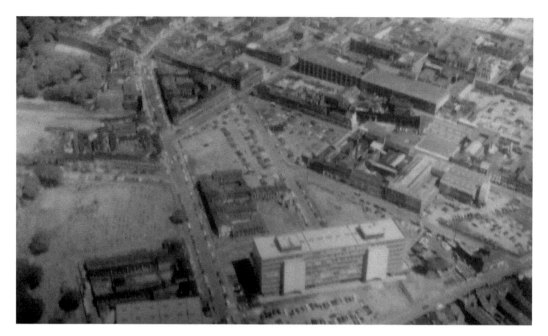

Flatted factories, a plan to mirror the Big Peg building across the Quarter. Thankfully it was never completed.

One of the more fanciful ideas for an information centre outside the Big Peg.

The refurbished Golden Square.

In fact when we initially started to develop the Golden Square concept, the Big Peg was owned by a charismatic London entrepeneur called Bennie Gray, who worked hand in glove with award-winning architects Glenn Howells. The initial proposal was for a transparent glass ball (in a nod to jewellery) to be the centrepiece, and also serve as an information centre. It would have certainly been a showstopper, but unfortunately never got past the drawing board.

Still, the final result is a decent one as the Square is a massive improvement on the previous car parking area. However, the result was not achieved without having to overcome a host of obstacles. The first was the need to have a budget for the upkeep of the Square, a condition that was imposed by the City Council's Highway's Department, who were to have the responsibility of the maintenance. This was eventually solved by including a new retail unit in the project proposal designed to fit in with the contemporary look of the Square and draw in an income through rent to cover the Square's maintenance costs.

The second was yet another argument over trees and, this time, the proposal to include some heritage apple trees. This idea was ditched due to the concern that the ground they were planted in was probably contaminated and could make the disastrous effects of Snow White's apple look comparatively innocuous.

For a time, we even discussed with the Big Peg building manager, a really creative guy called Dave Peebles, the idea of bringing back King Kong, an iconic piece of seventies public art beloved by Brummies of a certain age. The idea was to site him on the top of the Big Peg, where he could be seen for miles around. Unfortunately, we couldn't prise him away from the current owner, who lived in Scotland.

The new retail unit built to pay for the upkeep of the Golden Square.

A Brummie legend ... what might have been!

Either way, the Quarter now attracts increasing numbers of visitors and this is reflected in the growing numbers of hotels from the basic to the boutique accommodation around St Paul's Square.

It is also good to see one of Birmingham's few genuine good quality hostels on Livery Street. This is housed in a former factory where a version of the FA Cup was made, formerly known as Hatters Hostel. It is predictably a popular destination for young travellers and groups visiting Birmingham. There's even been a hotel with gold-coloured windows in Caroline Street, which to some may seem a little bit obvious but to others a very appropriate nod to its position in the Jewellery Quarter.

We did have an information centre near the clock in a small pavilion-style building constructed by the Prince's Foundation when Prince Charles was first involved in the Jewellery Quarter. It actually proved very popular and was a matter of pride for the member of our team that managed it.

Unfortunately, when our team folded through lack of funding the information centre closed. Birmingham has been poorly served in terms of manned information centres, which are seen by the local authority as unnecessary when most people have a mobile phone. This is a big mistake in my view; visitors far prefer and trust a human dimension when asking for advice.

Obviously signage is important and there are map totems around the area, which were installed to replace a network of heritage-style finger post signs. Whether these totems have done a good job, perhaps the jury is out given the number of squinting visitors around them which I have often seen on my still frequent visits to the Quarter. More important is the need for better signage in the main city centre

A popular high end hostel in Livery Street, housed in Vaughton Works – once makers of the FA Cup.

Bloc Hotel, in Caroline Street, with its gold-painted window frames.

Inside the old Jewellery Quarter Information Centre, in front of the Big Peg. This is now a distant memory supposedly superseded by the internet.

thoroughfares to raise the awareness about the proximity and ease of walking to the Quarter.

The lighting columns with jewellery-related wrought-iron designs give some sense of entry, but these are on the border of the Quarter when visitors are already in transit. So further signage is probably key to ensure a maximum number of people visit and enjoy the delights of what must be Birmingham's most historic area. Not to forget that many people still beat a path to the Quarter to simply buy jewellery because of the variety of expertise and the competition. Such competition usually means both quality and value for money can be achieved by the discerning shopper.

Either way it is a great place for somebody who wants something absolutely unique and bespoke and, in being part of the design process, it means that piece of jewellery will have its own story attached, which makes it extra special and unique.

So whether it's enjoying the Quarter's history and heritage, enjoying a gourmet meal, or a pint of crafted beer from one of the number of independent breweries now located in the Quarter, or most importantly buying something unique from the jewellers, the Jewellery Quarter has it all for a visitor to enjoy.

The exterior of the JQ Information Centre, housed in a 'pavilion' built by volunteers at the behest of Prince Charles.

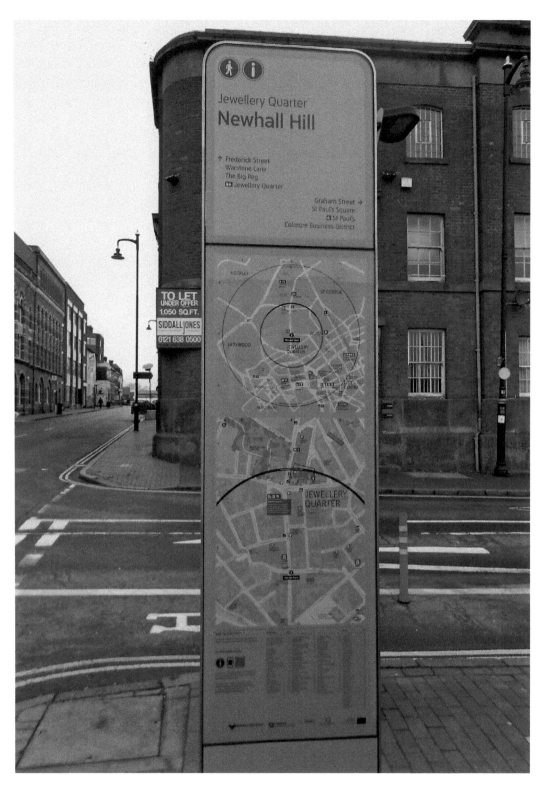

The new signage totems – confusing for some.

The old-style 3D map in Newhall Street, still used for orientation by visitors despite its age.

CHAPTER 7

Leaving A Legacy

After ten years, the regeneration landscape started to change as the City Council came under increasing pressure financially and the partly EU-funded Advantage West Midlands (basically a government quango) headed for oblivion.

The buzzword then and now for pilot initiatives is still 'succession strategy' and the natural direction to move in was the expanding, mainly private sector supported, Business Improvement Districts (BIDS).

Although the Jewellery Quarter Regeneration Partnership was not a BID, we were very much on the BID radar from our participation in their get-togethers so could see the opportunity to use the BID initiative to raise money and sustain the regeneration process in the Quarter. However, if we were to convert to a BID then we first had to convince the board of the Jewellery Quarter Regeneration Partnership. This was the comparatively easy bit because the challenge was then to get some fairly hard-bitten businesses and property owners to vote for the idea and to accept a surcharge on their business rates.

The initial step, in 2010, was to undertake a feasibility study and then hold a number of presentations to explain how a BID worked and the benefits. It soon became clear that this would not be an easy ask as predictably the initial general response from hard-pressed local businesses was 'Bloody Council, we already pay rates to fund things the Council should be doing' – and this was one of the more polite comments! Perhaps this was not helped by the fact that our partnership team had been leading on regeneration projects successfully for almost ten years so, to the average business, they would obviously question why things needed to change.

Apart from detailing the principle of BIDs, it was therefore vital that we showed the additionality (another buzzword) over and above what the Council were delivering. This proved difficult as suddenly City Council departments fell back on what was their statutory duty rather than what they were currently actually doing.

Pleading poverty, many of the Council departments obviously saw the BID as a salvation to their increasing hard-pressed resources. Some of our negotiations verged on the acrimonious as we tried to secure an accurate baseline on their services. The most difficult was usually when talking to middle rank officers defending their territory, with only the director level seeing the bigger picture and the need for compromise.

An extra complication was Birmingham City Council's ill-fated venture into the private sector when they put the maintenance of their highways into the hands of Amey.

This happened in an unholy rush and the Council paid the price by entering into an agreement before all the 'i's' were dotted and 't's' crossed. This meant that they were virtually powerless to negotiate effectively further down the line. Examples included vital issues such as maintenance cycles for highways and the criteria for repairing roads.

This was illustrated with the proverbial chestnut around the cost of planting trees, which became almost laughably expensive as Amey initially insisted on writing into the cost maintenance and deterioration for a ridiculous number of years, making tree planting on the highway almost unfeasible. Unsurprisingly, both parties are now withdrawing from this, in my opinion, ill-founded partnership.

The first step in developing the BID was to agree on the area, which was bounded by Great Charles Street, Livery Street, Great Hampton Street, Key Hill Drive, Icknield Street, and Sandpits/the Parade. The initiative was led by the independent Jewellery Quarter Development Trust, which had been set up following a regeneration summit to examine how things could be moved forward after the public sector-funded Jewellery Quarter Regeneration Partnership folded up. The Trust then set up a BID Committee with representatives from across sectors including hospitality, property and the jewellery sectors.

We organised it so that each Committee representative was responsible for influencing and persuading their both geographically and thematically relevant constituency. It was proposed that all businesses with a rateable value of £10,000 or above would pay an extra 2 per cent of rateable value to fund the BID, giving an annual budget of around £400,000. This was not a massive amount but had the potential to draw in other matched funding.

We then sent out a newsletter explaining how the BID would work and a questionnaire to hopefully gauge business priorities and feed that into the emerging prospectus. This was then hand delivered to the 500-or-so eligible businesses to ensure nobody could complain that they were not aware of the proposal.

Of course, it was a matter of judgement which ones to press bearing in mind the final election tally would relate to rateable value. Therefore securing the support of the big players was of paramount importance. If not, an equally effective result was when there was total apathy to the proposals and the business/landowner could not be bothered to vote either way as the result was judged on actual votes cast.

With the support of the national, but locally based, British Jewellers Association, we secured the support of most of the major jewellery manufacturers and with the help of the Jewellery Quarter Marketing Initiative we did the same with the shops, restaurants and bars. The local business-based Jewellery Quarter Association also helped to canvas support, and we reached a stage when we were only uncertain of a few voters.

The policy we adopted for these was to make sure they received all the correct notifications, but to leave it at that in the hope that even if they did not agree with the BID, they might well not bother to vote – an assumption that thankfully proved to be a sound one when a BID 'Yes' decision was recorded in 2012.

We consulted long and hard on the prospectus to not only secure buy-in but hopefully make it a prospectus that had something for everyone. Some years hence, the BID has been renewed, although it is quite interesting to look at the original prospectus and see what was actually delivered.

Objective A: Making the Jewellery Quarter more attractive, tidier and cleaner.

- A BID funded 'in bloom' initiative never really happened in a formal community initiative sense, but flowers and plants are BID-funded every year to add colour to the streets and is seen by many as part of the wider city centre initiative.

- Street tidying up, removing redundant signs and replacing/repainting traffic sign/lighting columns – no real progress, although the JQ BID funded a clean team to keep the streets generally tidy and litter free.

- Grants for temporary art schemes to improve the aesthetics of vacant/derelict buildings – this was never formally progressed, although bizarrely this particular artistic challenge was taken up unknowingly by Banksy, whose artwork suddenly appeared on the Jewellery Quarter station bridge. Probably, under the cover of night, he had used a bench to represent a sleigh as part of some artwork to highlight the plight of the homeless at Christmas. Needless to say, it became a much-visited attraction and photo opportunity!

- Working with the local Council to ensure proper enforcement of dereliction and other notices – lack of Council resources has meant this has never really been implemented with any vigour.

- A review of parking measures and adjustments where necessary – no real conclusion after several years due to the paucity of City Council resources.

- Working with land owners and developers to take advantage of grants and other funding – with the support of the Heritage Lottery Fund, this has become a welcome addition for some of the more architecturally important buildings in the Quarter.

Objective B: A safer Jewellery Quarter.

- Working with West Midlands Police to retain a high-profile presence in the Quarter, through the development of a combined police station reception/tourism information point – no surprise that this never happened thanks to massive police cuts resulting in the vacation of the police station.

- Introduce street wardens/JQ ambassadors – this happened.

- Working with the City Council and Amey to improve street lighting – a fairly sporadic and skimpy result, again down to resources.

Return of the Peaky Blinders? Quirky public art in Charlotte Street, still alive and kicking in the Quarter.

- Working to ensure a well-maintained CCTV scheme – the CCTV scheme has never been supplemented and is now moribund on the basis the cameras have become 'obsolete'.

Objective C: Promoting the Quarter as a unique place to work, visit, live and invest.

- Investment campaign with Marketing Birmingham (now the West Midlands Growth Company) – nothing concerted happened, probably because the Jewellery Quarter and most of the allied attractions were not members of the organisation.

Banksy, as usual, created an overnight sensation – this time on Vyse Street in the Quarter.

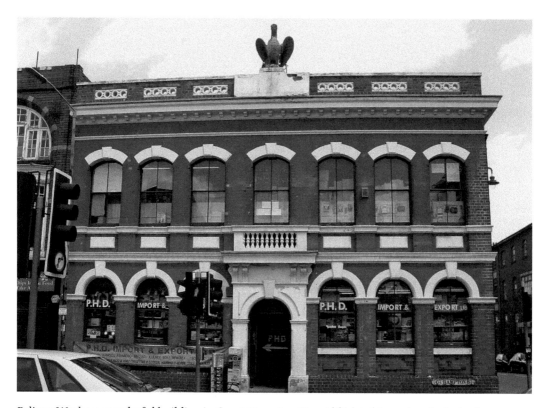

Pelican Works, a wonderful building in Great Hampton Street blighted for a time by lack of care and poor planning enforcement.

Squirrel Works, a very successful conversion – though the loft area is architectural marmite to some.

- Introduction/continuance of festivals, events and markets to promote the Quarter – the JQ BID undertook a substantial programme following on from the work undertaken pre-BID.

- Retaining and expanding the Christmas lights – new themed lights have been introduced each year to retain the uniqueness of the display.

- Proactive management of a Jewellery Quarter website and introduction of a publication of a magazine – fully achieved.

Objective D: supporting business growth

- Using the main JQ website for B2B – a directory was compiled.

- Working with Birmingham City Council and other partners to secure funding to promote a centre of excellence for exhibitions and sales – never progressed due to funding issues. However, thanks to a forward-thinking designer maker Michele White, a centre was set up in Caroline Street (the Artisan Alchemy) where leading-edge furniture and jewellery design can be enjoyed, bought and commissioned. There are also jewellers workshops, and while the scheme received some EU funding, this still involved substantial risk taking by Michele when the public sector weren't willing to invest.

- Working with a local medical practice and Primary Care Trust on health promotions/screening of local businesses – never really progressed.

- Introducing a series of business networking events in partnership with the Jewellery Quarter Association – a fairly regular feature.

- Supporting the Jewellery Trade through incubation schemes and resurrecting the successful Brilliantly Birmingham event – never progressed in that form.

- Working with environmental agencies on potential for self-financing/block purchase of recycling schemes – never progressed.

Objective E: A better-connected Quarter

- Working to introduce a new wayfinding scheme to help visitor orientation – this has been achieved through the signage totems, although their effectiveness could be questioned.

- Development of low-cost travel schemes/cycling provision – this was in development with a major citywide strategy being developed by the Council.

- Working in partnership with Birmingham City Council and Colmore Row BID to deliver improved connections to the city centre – some low budget improvements have been carried out to the Ludgate Hill bridge and the wider Paradise Circus scheme should be of major benefit. In fairness this is a longer term strategy, although sadly walking through the dank Livery Street underpass remains a challenge for many people. Of course, the excuse for the low budget improvements to the bridge was that this was going to be temporary measure until a new graded crossing was constructed. Many years on this has never happened, and this is a typical example of the local authority waiting for a perfect solution that never actually transpires.

- Working with Digital Birmingham and bandwidth providers to ensure the Quarter is a priority in terms of fast bandwidth – ongoing, although whether the Quarter is seen as a priority is debatable.

Objective F: Championing the Quarter

Looking at these outcomes, it is questionable whether even half of the original prospectus has been delivered. However, this is not necessarily a criticism of the BID, priorities change and much of the failure to achieve has been caused by proposed partners – from the Council to the police – being ever more strapped for funds.

 Of course, while the BID may be the champions for improvements to the area, it has to be remembered that their duty is primarily to their levy payers. Set against this is a very sizeable residential population and a large number of small businesses who are either ineligible or fall below the levy paying threshold, sometimes with different priorities to the levy payers.

The Artisan Centre in Caroline Street, an ambitious project driven by designer maker Katherine Campbell-Legge, aimed at showcasing innovative design.

The cause of the residents has been taken up by the Jewellery Quarter Neighbourhood Forum (JQNF), which we started as an informal group to represent residents but later morphed into a more formal entity. Their main aim has been the development of a Neighbourhood Plan, which has the same status as a statutory document. The Forum have worked very hard on developing the document and consulting, but there must be concern that many of these residents are not necessarily in tune with the jewellery industry.

There is a paramount need to retain some significant semblance of the industry if the area is to remain truly unique. Otherwise it will just be another gentrified area with lots of restaurants and bars but very little else, and will lose its place as an area absolutely unique in the UK. This is endorsed by Historic England, who reference the area's industrial ecology and the fact that many of the buildings were specifically designed to accommodate the jewellery industry. Therefore, keeping the industry alive helps give these historic buildings a purpose and reason to exist.

The other concern is that with so many occupied apartment blocks (many with limited access) scattered right across the area, true democratic representation could become an issue. In other words, if the JQNF representation increases mainly through close social contact then there is likely to be geographic clustering even within apartment blocks or just involving neighbours, leaving large parts of the population effectively disenfranchised.

The one real safeguard against this is the use of spreading the word through social media like the popular resident-run 'myjq'. The brainchild of a local resident, Brian Simpson, it became *the* place to keep a finger on the Jewellery Quarter pulse. The concern over

achieving wider community representation is in no way a criticism of the sterling work undertaken by the JQNF, but merely a fact of life in that clustering is always likely to be an issue in 'closed' communities – hence the importance of social media.

Overall, the presence of both a JQ BID and the Neighbourhood Forum can only be a force for good in the area – particularly when it is competing for resources and soon to be devoid of access to EU funding. However, the key to the future of the Jewellery Quarter as a mixed use area may well be the Paradise Circus scheme, the proposals to traffic calm and restructure Great Charles Street and the development of the large site fronting Lionel Street.

All these things will bring the Quarter into the mind's eye of the city's wider residents and visitors and as long as the planners don't completely tear up the Conservation Management Plan protection, there is every reason to be optimistic about the future of this particular Urban Village.

CHAPTER 8

Some Lessons Learned

The period of regeneration covered in this book has had its highs and lows and there are lessons to be learned from a regeneration professional's point of view.

Dealing with bureaucracies like councils and government quangos was usually a matter of striking up a good working relationship with individuals. Predictably, they all seem to work in silos and their interests were generally confined to their own patch, which they protected with a parochial passion.

In our experience, the best approach was to strike up a dialogue both with the front line troops who would be delivering at the sharp end and also at senior director level, who could see things strategically. In fact, the most difficult tier was the senior managers below senior director level who tended, with a few notable exceptions, to be traditional stick in the muds, generally averse to change and often more of a hindrance than a help.

Similarly, dealing with government departments could be a frustrating experience with their penchant for picking faults rather than being creative and helping make things happen by providing positive advice. Unfortunately, this negative approach was too often the case in my experience as their workforce were generally not risk takers and would be reluctant to move a muscle unless everything was 100 per cent certain and risk-free. A recipe for never getting things done, but no doubt the ideal approach to securing a promotion on the basis of never making a mistake!

Working with a community, both residential and business, was helped by the plethora of organisations already around in the Quarter but, of course, they all had their own agendas. Once we pragmatically accepted this as the norm, it was still important to use their expertise and undoubted 'clout'.

Like most organisations, the community tended to be polarised geographically or thematically within the Quarter, but nevertheless proved to be a good sounding board to make sure we were in touch with the community 'pulse'.

Another benefit of this close liaison was the kudos that this earned with politicians (generally councillors but also MPs) who as always (with a few exceptions) were keen to farm votes and influence.

Planning was perhaps (even above parking) the hottest topic in the Quarter and the fairly stringent Conservation Management Plan generally kept the area's physical integrity

intact, although as previously mentioned both the Conservation Management Plan and the Design Guide should have ideally been in place earlier when the Urban Village initiative was announced. The lesson learned there was the need to get all the ducks in a row first before announcing an initiative that was bound to heat up land prices.

Similarly, it was no use pretending that the local authority had the resources for effective enforcement so direct contact with landowners reinforcing the 'threat' of enforcement was the best course of action in the circumstances – usually a bluff, but it often worked well.

On planning issues, the community involvement in planning gain was critical in keeping local goodwill and was also critical in securing match funding to double its value to the Quarter. With all projects the aim was always to benefit the community because they were the ones that had to live and work in the area. Any sort of big brother 'we know best because we're the experts' approach would have been doomed to failure.

In developing an Action Plan we made sure that it had a balance between exciting or flagship projects and the mundane. To many communities (including the Quarter) issues such as clean and safe streets are always priorities and are ignored at the peril of any regeneration initiative. The expression 'all fur coat and no knickers' springs to mind when the basics are left undone.

In terms of the way the Quarter initiative was delivered, it convinced me that a geographical focus concentrated the mind and harnessed the passion of the community, providing real additionality. In regeneration, purists always expound a theory that 'main programme bending' was a panacea to change, but in my experience this rarely came to pass. Cash-strapped local authorities rarely have the flexibility to take that approach, so a geographical approach was usually the only effective way forward to change in areas.

The other major benefit to a local initiative was having a local team on the ground, rather than in a perceived ivory tower. It engendered the trust of the local community because they knew we were always accessible, and the loyalty of the regeneration team was always an important plus because they identified with the area and the community on a day-to-day basis. Long hours were worked to ensure no telephone calls or e-mails were left unanswered.

Another benefit was that centrally based departments such as the local authority or the government always looked to geographical area teams for advice because of their local know-how. This also meant that having local thematic groups for topics as Community Safety, Land and Property, and Marketing brought a clear focus on issues faced by the Quarter with genuine community input.

In summing up the regeneration of the Quarter, I thought that it would be interesting to hear the views of a property professional based in the Quarter and also to talk to a regeneration expert who was in involved with the Quarter in the 1980s.

First I spoke to Philip Jackson. Philip is one of the founders of Maguire Jackson, arguably the biggest estate agents in the Quarter. He moved into the area in 2008 having spent some formative years around Clerkenwell and Shoreditch and Philip told me that he saw many similarities with the Quarter.

I asked him what he felt was the key to ensuring the regeneration of the area was not also its ruination as a historical and unique area, and he unhesitatingly said that it was

the capping of developments to four storeys high. We talked about the apparent lack of diversity in terms of the residential population and Philip's view was that many young members of Birmingham's Asian community still tended to live with larger family units. However, he did say that the area was popular with the gay community, where the issue of lack of facilities for children tended to be a less important issue. He added that the area also attracted older people who wanted to downsize.

Philip felt that City Council's Conservation Management Plan had generally been a good thing in keeping a balance and he pointed out that the area's quirkiness, facilities and proximity to the city centre were attracting an increasing number of IT and creative firms.

As regards to jewellery and the manufacturing industry, his view was that some of the larger firms might move their actual manufacturing outside the area, releasing land and property while keeping a smaller research, design and possibly retail presence left in the area. This is already happening, as exemplified by long-established firms such as A.E. Harris and Baker & Finnemore – although in both those two cases, they had now moved out of the area completely.

Regarding the current planning process, he felt that the process should be made easier to assist in refurbishment projects and that the Jewellery Quarter Neighbourhood Forum and Business Improvement District should have a significant say in how the Community Infrastructure Levy was used.

All things said and done, from an estate agent's viewpoint, Philip's general feeling about the area was one of real positivity.

I then spoke to Peter White, a regeneration expert who had been involved in the Quarter through the delivery of number of important projects. Most notably, Peter had masterminded the setting up of Midlands Industrial Association, who continue to provide affordable workspace in various locations – most notably in the Jewellery Quarter. In fact their headquarters is still in the Argent Centre in Frederick Street, arguably the most important Jewellery Quarter building in terms of its architecture and location in the area as a gateway.

Peter told me that, in the eighties, London-based regeneration consultants URBED had been commissioned by Birmingham City Council to prepare a regeneration strategy for the Jewellery Quarter. Perhaps one of the most important of their ideas to come to fruition was a Jewellery Quarter Heritage Centre in the form of the iconic Museum of the Jewellery Quarter. They had subsequently been asked by the Department of Environment to develop a good practice guide on the renewed use of redundant buildings, and they selected the Argent Centre as one example, which by then had been converted into managed workspace.

I asked for Peter's view on the regeneration of the area following the announcement of the Urban Village initiative. He felt that, at the time, the City Council had seemed reluctant to enforce planning regulations, for instance failure by developers to adhere to planning conditions resulting in poor quality schemes that contributed negatively to the street scene. Owners of listed buildings had not been forced to take responsibility for their repair obligations and hence several key buildings had become 'at risk', or even passed the point of no return.

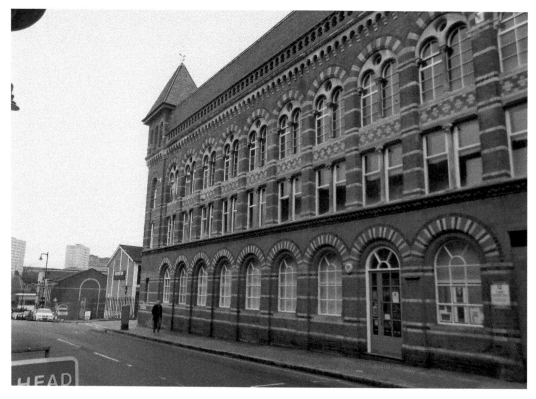

The Argent Centre in Frederick Street, one of the Quarter's showpiece buildings. It is owned by workspace provider Midland Industrial Association.

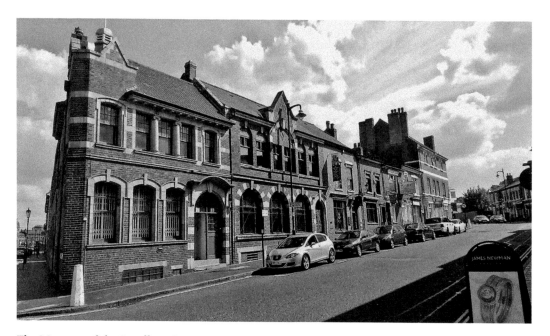

The Museum of the Jewellery Quarter in Vyse Street.

The *City of Birmingham* steam loco leaving the Jewellery Quarter's old Science Museum for its
new home at Millenium Point.

Regretfully, some of these owners/developers were local people who put personal gain before the longer term benefit of the Quarter. There were some notable exceptions whose contributions to the area needed to be commended.

To be fair to the Council, for many years it has lacked resources needed to strictly administer the planning system in parts of the city like the Jewellery Quarter. However, this may have been exacerbated by a sense that it wasn't considered a priority in terms of what it could contribute to Birmingham. The numerous interests, strong local characters and fiercely independent people have never been easy to deal with and it is often put

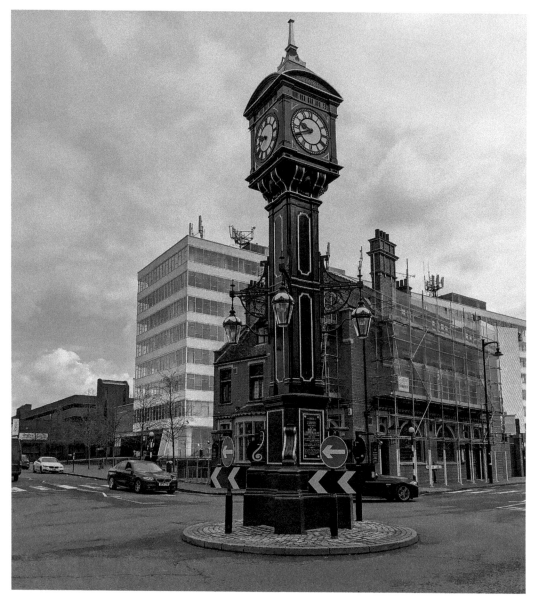

The iconic Jewellery Quarter clock, lovingly restored.

on the back burner, particularly with perceived bigger fish to fry elsewhere in the city delivering quicker and more lucrative returns.

Distinctiveness is only now being recognised for its value in terms of attractiveness, place making and quality of life. Unfortunately, in the meantime, some truly ghastly schemes have been allowed and the area has suffered as a result. Peter asked, 'how much damage will these inflict on the Quarter?'

Finally, I asked him about how he would like to see the Jewellery Quarter progress in the future. On the plus side, Peter felt that there was definite potential to strengthen the area's creative economic base. However on the negative side, his caveat was that the massive economic impact of the COVID-19 pandemic could mean that support for heritage would take a back seat for a lengthy period, which could obviously threaten the area's historical integrity. The continuing market pressures might prove too strong for the local planning authority to control, especially if there wasn't the political will to enforce the local plan and resist inappropriate development.

One thing is certain: we both felt that the Jewellery Quarter could be, and probably already is, the city of Birmingham's most valuable asset, particularly in terms of its history and architecture.

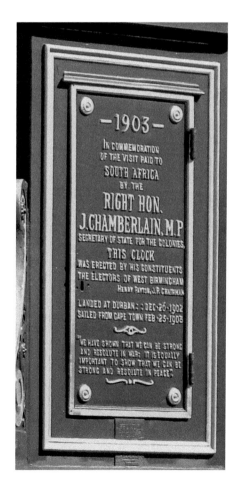

The clock's original commemorative plaque, controversially celebrating Joseph Chamberlain's work in the 'Colonies'.

Acknowledgements

Firstly with regard to this book itself, I want to thank Dr Carl Chinn for his excellent foreword as Birmingham's leading social historian. In addition, thanks go to those who supplied and allowed me to use photos – particularly Anna Gibson, Neil Grant, Marie Haddleton, James Newman, Simon Topman and Peter White. On the subject of photos, my thanks must also go to Rob Stanyard from the Pen Museum for all his work in ensuring that all those photographs passed muster with Amberley's technical requirements.

A number of people were interviewed for this book, namely Matthew Bott, Greg Fattorini, Neil Grant, Marie Haddleton, Philip Jackson, James Newman, Simon Topman, and Peter White and thanks go to all of them for their time and frankness.

With regard to the actual regeneration of the Quarter, my team endured many comings and goings but I particularly want to highlight three people. Anna Gibson, the partnership's marketing director, whose ideas, creativity and fundraising skills were second to none; Prim Currie, who was always a reliable and safe pair of hands when needed; and our information centre queen, Mary Bradley.

At the City Council, I want to particularly thank Mark Gamble in the Planning Department, Russell Poulton, my minder in the Economic Development Unit, and, at Councillor level, Carl Rice and Phil Davies. Last but not least, the Economic Development Director, the brilliant Clive Dutton and his successor Waheed Zahir, all now sadly deceased.

In the Civil Service, Philippa Holland who allowed me to get on with things, John Dickenson who handed over the JQ baton to me in a measured way and both Martin Molloy and Terry Cotton who played major roles in securing the successor body of the Jewellery Quarter Business Improvement District.

Last but not least, a supportive local community headed by the irrepressible Marie Haddleton, Ross Bellamy and the sadly deceased Kenny Schofield, John Bunce (Jam House), Dave Peebles (formerly the Big Peg), Rev. Tom Pyke, and Dave Mahony to name a few.

Finally, I can't forget the jewellery industry community, where thanks should particularly go to Peter Taylor (now Goldsmiths Company). Apologies to the many people I've undoubtedly omitted who were helpful and supportive in making sure that our Regeneration Initiative reached most of its targets.